Permanent Red

John Berger is unique among contemporary writers. His work is marked by a genuine, uncompromising social commitment. Each of his writings signals a new departure in the interplay between writer, subject matter and reader; a fresh attempt to find a form which best communicates the material at hand.

Berger's work includes fiction: *A Painter of Our Time* (1958), *The Foot of Clive* (1962), *Corker's Freedom* (1964), *G.* (1972); documentary essays which combine text and images in a radically new way: *A Fortunate Man* (with Jean Mohr, 1967), *Ways of Seeing* (1972), *A Seventh Man* (with Jean Mohr, 1972); books on art: *Success and Failure of Picasso* (1965), *Art and Revolution* (1969); collections of essays and articles: *Permanent Red* (1960), *The Look of Things* (1972); and the filmscripts: *Salamandre, The Middle of the World*, and *Jonas who will be 25 in the year 2000*.

John Berger was born in London in 1926. He attended the Central and Chelsea Schools of Art and began his working life as a painter and teacher of drawing. He now lives and works in a small French peasant community with his family. This milieu has provoked his most imaginatively complex work to date: *Into Their Labours*, a three-part project which evokes, analyzes and records, in both fiction and essay form, the intricate movement from peasant society to metropolis.

PERMANENT RED

Essays in Seeing by

JOHN BERGER

Writers and Readers

Writers and Readers Publishing Cooperative Ltd.
25 Nassington Road London NW3
175 Fifth Avenue New York, NY 10010
First published in Great Britain by Methuen and Co. Ltd. 1960
This edition published by Writers and Readers Publishing
Cooperative 1979. Reprinted 1981.

Printed in Canada by the Hunter Rose Co. Ltd., Toronto

SBN 0 904613 92 5

Contents

PREFACE *page* 7

INTRODUCTION 13

WHO IS AN ARTIST? 19

DRAWING 23

THE DIFFICULTY OF BEING AN ARTIST 31

ARTISTS DEFEATED BY THE DIFFICULTIES 58

ARTISTS WHO STRUGGLE 83

TWENTIETH-CENTURY ART 106

TWENTIETH-CENTURY MASTERS 111

THE LIFE AND DEATH OF AN ARTIST 142

LESSONS FROM THE PAST 151

THE FUTURE 205

USEFUL DEFINITIONS 208

A MORAL 214

INDEX 219

For my Mother and Father
who wanted me to learn

Preface

This book was first published in 1960. Most of it was written between 1954 and 1959. It seems to me that I have changed a lot since then. As I re-read the book today I have the impression that I was trapped at that time: trapped in having to express all that I felt or thought in art-critical terms. Perhaps an unconscious sense of being trapped helps to explain the puritanism of some of my judgments. In some respects I would be more tolerant today: but on the central issue I would be even more intransigent. I now believe that there is an absolute incompatibility between art and private property, or between art and state property — unless the state is a plebeian democracy. Property must be destroyed before imagination can develop any further. Thus today I would find the function of regular current art criticism — a function which, whatever the critic's opinions, serves to uphold the art market — impossible to accept. And thus today I am more tolerant of those artists who are reduced to being largely destructive.

Yet it is not only I who have changed. The future perspective of the world has changed fundamentally. In the early 1950's when I began writing art criticism there were two poles, and only two, to which any political thought and action inevitably led. The polarization was between Moscow and Washington. Many people struggled to escape this polarization but, objectively speaking, it was impossible, because it was not a consequence of *opinions* but of a crucial world-struggle. Only when the USSR achieved (or was recognized to have

achieved) parity in nuclear arms with the USA could this
struggle cease to be the primary political factor. The achieving
of this parity just preceded the Twentieth Congress of the
CPSU and and the Polish and Hungarian uprisings, to be
followed later by the first obvious divergences between the
USSR and China and by the victory of the Cuban Revolution.
Revolutionary examples and possibilities have since
multiplied. The raison d'être of polarized dogmatism has
collapsed.

I have always been outspokenly critical of the Stalinist
cultural policy of the USSR, but during the 1950's my criticism
was more restrained than now. Why? Ever since I was a
student, I have been aware of the injustice, hypocrisy, cruelty,
wastefulness and alienation of our bourgeois society as
reflected and expressed in the field of art. And my aim has
been to help, in however small a way, to destroy this society. It
exists to frustrate the best man. I know this profoundly and am
immune to the apologetics of liberals. Liberalism is always for
the alternative *ruling* class: never for the exploited class. But
one cannot aim to destroy without taking account of the state
of existing forces. In the early 1950's the USSR represented,
despite all its deformations, a great part of the force of the
socialist challenge to capitalism. It no longer does.

A third change, although trivial, is perhaps worth
mentioning. It concerns my conditions of work. Most of this
book was first written as articles for *The New Statesman*. They
were written, as I have explained, at the height of the Cold
War during a period of rigid conformism. I was in my 20's (at
a time when to be young was inevitably to be patronized).
Consequently every week after I had written my article I had to
fight for it line by line, adjective by adjective, against constant

editorial cavilling. During the last years of the 1950's I had the support and friendship of Kingsley Martin, but my own attitude towards writing for the paper and being published by it had already been formed by then. It was an attitude of belligerent wariness. Nor were the pressures only from within the paper. The vested interests of the art world exerted their own through the editors. When I reviewed an exhibition of Henry Moore arguing that it revealed a falling-off from his earlier achievements, the British Council actually telephoned the artist to apologize for such a regrettable thing having occurred in London. The art scene has now changed. And on the occasions when I now write about art I am fortunate enough to be able to write quite freely.

Re-reading this book I have the sense of myself being trapped and many of my statements being coded. And yet I have agreed to the book being re-issued as a paperback. Why? The world has changed. Conditions in London have changed. Some of the issues and artists I discuss no longer seem of urgent concern. I have changed. But precisely because of the pressures under which the book was written — professional, political, ideological, personal pressures — it seems to me that I needed at that time to formulate swift but sharp generalizations and to cultivate certain long-term insights in order to transcend the pressures and escape the confines of the genre. Today most of these generalizations and insights strike me as still valid. Furthermore they seem consistent with what I have thought and written since. The short essay on Picasso is in many ways an outline for my later book on Picasso. The recurring theme of the present book is the disastrous relation between art and property and this is the only theme connected with art on which I would still like to write a whole book.

Permanent Red

The title *Permanent Red* was never meant to imply that I
would not change. It was to claim that I would never
compromise my opposition to bourgeois culture and society. In
agreeing to the re-issue of the book I repeat the claim.

<div align="right">John Berger, 1968/1979</div>

Acknowledgement

I would like to thank the *New Statesman* for permission to
republish much material that now forms the basis of this book.

On a Degas bronze of a dancer

You say the leg supports the body
But have you never seen
The seed in the ankle
 Whence the body grows?

You say (if you are the builder of bridges
I think you are) each pose
Must have its natural equilibrium
But have you never seen
Recalcitrant muscles of dancers
 Hold their unnatural own?

You say (if as rational
As I hope you are) the biped's evolution
Was accomplished long ago
But have you never seen
The still miraculous sign
A little in from the hip
Predicting nine inches below
 Bodies fork in two?

Then let us look together
(We who both know
Light's the go-between
Of space and time)
Let us look at this figure
To verify
 I my goddess
 And you the stress.

Think in terms of bridges.
See, the road of leg and back
Hingeing at hip and shoulder
Holds firm from palm to heel
Single leg as pier
Thigh above the knee
Cantilevering member.

Think in terms of bridges
Over what men once called Lethe.
See, the ordinary body we cross through
Vulnerable, inhabited, warm
Stands the strain too.
Dead Load, Live Load
And Longitudinal Drag.

So let the bridge this dancer arches for us
Stand the strain of all old prejudice
So let's verify again,
 You my goddess
 And I the stress.

Introduction

If you take a long-term historical view, ours is obviously a period of mannerism and decadence. The excessive subjectivity of most of our art and criticism confirms this. The historical and social explanations are not hard to find. It may be unpopular but it is not stupid to condemn works as bourgeois, formalist and escapist.

If, on the other hand, you take a very limited view it is possible to sympathize with almost all artists. If you accept what they themselves are trying to do, you can admire their effort. The work is then no longer proof of the validity of the artist's intentions: his intentions have to prove the validity of his work. If you want to know what it feels like to be X, his paintings will tell you as much as anything else ever will. Accept that it is necessary for him to create a kind of tidal world of flux in which solidity, weight and identity are all sucked away, and then his paintings are certainly impressive.

The limitation of the first approach is that it tends to be over-mechanical. To take a long-term historical view you must stand outside your own time and culture. You must base yourself on the past, in an imaginary future or in the centre of an alternative culture. Your general opinion will probably be right. But you will almost certainly be blind to the processes by which your own period is changing itself. You will tend to see the dramatic break between the culture with which you identify yourself and the culture

that surrounds you more clearly than you will see the dialectic leading up to and away from that break. You would, for instance, have seen that Surrealism was decadent but you would have failed to understand how it nourished Eluard who later opposed all decadence. It is an approach that assumes that your own period is finished rather than continuous.

The limitation of the second way of approach is its subjectivity. Intentions count for more than results. You judge the distance travelled instead of the distance still necessary to travel. You think as though history begins afresh with each individual. Your mind is open – but anything can enter it and so seem positive. You will admit the genius and the fool – and not know which is which.

So what is required is a combination of both approaches. Then you will be fully equipped to recognize that rare transformation which, when it happens, allows an artist's pursuit of his personal needs to become a pursuit of the truth. You will have the historical perspective necessary to evaluate the truth he discovers, and you will have the imaginative appreciation necessary to understand the route he must take to travel towards his discovery. In theory, such a combination would equip the ideal critic. But in fact it is impossible.

The two approaches are mutually opposed. You are demanding that the critic is simultaneously in one place (in X's imagination) and everywhere (in history). You are casting him for the role of God. Which is, of course, the role most critics cast for themselves. Their one concern and one fear is that they will fail to understand the next genius, the latest discovery, the newest trend. Yet they are

Introduction

not God. So they wander about, looking for they know not what, and always believing that they have just found it.

Proper criticism is more modest. First, you must answer the question: What can art serve here and now? Then you criticize according to whether the works in question serve that purpose or not. You must beware of believing that they can always do so directly. You are not simply demanding propaganda. But you need not fall over backwards in order to avoid being proved wrong by those who later take your place. You will make mistakes. You will miss perhaps the genius who finally vindicates himself. But if you answer your initial question with historical logic and justice, you will be helping to bring about the future from which people will be able to judge the art of your own time with ease.

The question I ask is: Does this work help or encourage men to know and claim their social rights? First let me explain what I do not mean by that. When I go into a gallery, I do not assess the works according to how graphically they present, for example, the plight of our old-age pensioners. Painting and sculpture are clearly not the most suitable means for putting pressure on the government to nationalize the land. Nor am I suggesting that the artist, when actually working, can or should be primarily concerned with the justice of a social cause.

> *Shut the door of the Pope's chapel,*
> *Keep those children out.*
> *There on that scaffolding reclines*
> *Michael Angelo.*
> *With no more sound than the mice make*

Permanent Red

His hand moves to and fro.
Like a long-legged fly upon the stream
His mind moves upon silence.

Yeats understood the necessary preoccupations of the artist.

What I do mean is something less direct and more comprehensive. After we have responded to a work of art, we leave it, carrying away in our consciousness something which we didn't have before. This something amounts to more than our memory of the incident represented, and also more than our memory of the shapes and colours and spaces which the artist has used and arranged. What we take away with us – on the most profound level – is the memory of the artist's way of looking at the world. The representation of a recognizable incident (an incident here can simply mean a tree or a head) offers us the chance of relating the artist's way of looking to our own. The forms he uses are the means by which he expresses his way of looking. The truth of this is confirmed by the fact that we can often recall the experience of a work, having forgotten both its precise subject and its precise formal arrangement.

Yet why should an artist's way of looking at the world have any meaning for us? Why does it give us pleasure? Because, I believe, it increases our awareness of our own potentiality. Not of course our awareness of our potentiality as artists ourselves. But a way of looking at the world implies a certain relationship with the world, and every relationship implies action. The kind of actions implied vary a great deal. A classical Greek sculpture increases our awareness of our own potential physical dignity; a Rembrandt of our potential moral courage; a Matisse of our

potential sensual awareness. Yet each of these examples is too personal and too narrow to contain the whole truth of the matter. A work can, to some extent, increase an awareness of different potentialities in different people. The important point is that a valid work of art promises in some way or another the possibility of an increase, an improvement. Nor need the work be optimistic to achieve this; indeed, its subject may be tragic. For it is not the subject that makes the promise, it is the artist's way of viewing his subject. Goya's way of looking at a massacre amounts to the contention that we ought to be able to do without massacres.

Works can be very roughly divided into two categories, each offering, in the way just described, a different kind of promise. There are works which embody a way of looking that promises the mastering of reality – Piero, Mantegna, Poussin, Degas. Each of these suggests in a different way that space, time and movement are understandable and controllable. Life is only as chaotic as men make it or allow it to be. There are other works which embody a way of looking whose promise lies not so much in any suggested mastery, but rather in the fervour of an implied desire for change – El Greco, Rembrandt, Watteau, Delacroix, Van Gogh. These artists suggest that men in one way or another are larger than their circumstances – and so could change them. The two categories are related, perhaps, to the old distinction between Classic and Romantic, but they are broader because they are not concerned with specific historical vocabularies. (It is obviously absurd to think of El Greco as a romantic in the same sense as Delacroix or Chopin.)

Permanent Red

All right, you may now say, I see your point: art is born out of hope – it's a point that's often been made before, but what has it to do with claiming social rights? Here it is essential to remember that the specific meaning of a work of art changes – if it didn't, no work could outlive its period, and no agnostic could appreciate a Bellini. The meaning of the improvement, of the increase promised by a work of art, depends upon who is looking at it when. Or, to put it dialectically, it depends upon what obstacles are impeding human progress at any given time. The rationality of a Poussin first gave hope in the context of absolute monarchism: later it gave hope in the context of free trade and Whig reforms; still later it confirmed Léger's faith in proletarian Socialism.

It is our century, which is pre-eminently the century of men throughout the world claiming the right of equality, it is our own history that makes it inevitable that we can only make sense of art if we judge it by the criterion of whether or not it helps men to claim their social rights. It has nothing to do with the unchanging nature of art – if such a thing exists. It is the lives lived during the last fifty years that have now turned Michelangelo into a revolutionary artist. The hysteria with which many people today deny the present, inevitable social emphasis of art is simply due to the fact that they are denying their own time. They would like to live in a period when they'd be right.

Who is an artist?

You are lying on the grass in the sun. Above you is a beech tree. A slight wind lifts the lighter branches and turns the leaves. From a distance this constant movement of the leaves makes it look as if green snow is falling in front of the tree's green surface – just as once silvery snow seemed to fall in front of the grey cinema screens.

Through half-closed eyes you gaze up. They are half-closed because you are watching intently. One bough extends further than the others. It is impossible to count the number of leaves on it. The blue sky which you see through and around these leaves is like the whiteness of paper round the letters of words. The distribution of the leaves against the sky seems far from arbitrary. You find yourself wondering whether it might not be possible to explain their sequence as one can explain the sequence of letters and words in a book. Then you discover an image which, like a good teacher, gives direction to your confused thinking. Everything – you begin to say to yourself – in order to achieve existence at all, must pierce the very centre of a target; anything which misses that centre simply does not exist. But a teacher's words after he has gone often prove a disappointment. So you are left puzzling how the bough above you can be said to represent the entire Spring. . . . Thinking like this you may be a philosopher, but I don't think you're a painter.

You are lying with your head on your carefully folded jacket. The tree, you calculate, must be a good sixty feet

tall. Can you discover any buds? You screw up your eyes. There are none left. Things must be at least a fortnight further advanced than at home. It's lower, of course, and protected by the Downs. Then you try to see if you can distinguish the inconspicuous flowers. The bough is too high and the light is too bright. You remember that during famines men ate beech fruit. After all, the beech belongs to the same family as the sweet chestnut; and pigs are turned into beech woods in the autumn. But then pigs eat anything. Your eye travels along the bough. Its shape is like the outline of a horse's hind leg seen from the side. You are becoming sleepy, but as you look up you imagine throwing a rope over that bough. You are no longer thinking, you are drifting, and your eyes are almost shut. Yet the palms of your hands and insides of your knees go tense at the memory of climbing along such twisting branches as a child. For you the parts of the tree are there to master in one way or another . . . but not through painting.

Idly and every so often you close your eyes. Then the image of the pattern of the leaves remains for a moment before it fades, imprinted on your retina, but now deep red, the colour of the darkest rhododendron. When you re-open your eyes the light is so brilliant that you have the sensation of it breaking against you in waves, reminding you of how small an island you are in the grass. You are aware of the children playing around you, and by some association too quick for you to notice – although you will remember it in retrospect – you marvel at how many birds a tree can hide. At dusk, when a man approaches, a flock of forty or fifty starlings can scatter upwards from a single

may tree to circle the sky once more; like painted birds on a fan suddenly opened and then slowly shut again. The tree is full of incidents, imagined and remembered. But for you, above all, this tree exists in time, and its size and its green-ness and the reasoning of the man who originally planted it, no less than the reasoning of the man who may order it to be felled, all remind you of this fact. Suddenly you notice that the sky is not a uniform blue. There, above the tree, is a vertical streak of paler blue, branching out at its top end in several directions. In fact, it's like a tree itself, you say. Then you watch it change into a lion's head. . . . You are using your eyes – like a poet perhaps; but not like a painter.

You lie there. You can smell the grass. You are more than usually conscious of the warmth of the sun. You have the sensation that you are stretched across the world and so can feel the curve of the earth. Nothing about the tree surprises you. You look at it as an actor may look at the auditorium. And your drama? Your arm is round another waist; a hand strokes through your hair. You may be anybody, but at the moment you see the tree as only a lover sees it. The tree is an X marking a spot for you both.

You do not look. What sense is there in lying down if you still have to use your eyes? You half listen to the wind. The leaves sound like sand being tipped. When you wake you look up very warily. You see green, blue, green mixed with dirt, white. The green has taken every trace of yellow out of the blue. That fact is certain. Everything else is confused. Without concentrating very hard and, as if with your hands, you begin to sort out what you can see. Imitating the skill of the flowersellers who know exactly which

sprig to put with which, you learn to distinguish the swags of foliage, allotting each to its own branch and to its own proper position in space. You begin to test the angles of the branches, like a fitter, not like a mathematician. You do your best to belittle that tree: to reduce it to a tangible size and simplicity. You close your eyes again. But now you are concentrating. You are thinking of your own painting. How can it adapt itself to admit such a tree? How can it keep such a tree in its proper place? Gradually you are able to imagine it appearing in your painting. Yet at the moment it is scarcely more than a sign made with your own fingers like the church steeple and the parson. But you are no lumberjack: you can't transport trees and roll them. Nor can you plant them in your soil from seeds. When you open your eyes to look at the actual tree you try your hardest to see it as you have just imagined your painted tree. But you can't. It remains there towering against the sky. You belittle it again. Close your eyes once more. Adapt the tree that belongs to your painting. Open and check. It is closer, but the beech still towers and shimmers above you. Again and again. And so you may lie until it is dark . . . and be a painter.

The basis of all painting and sculpture is drawing

For the artist drawing is discovery. And that is not just a slick phrase, it is quite literally true. It is the actual act of drawing that forces the artist to look at the object in front of him, to dissect it in his mind's eye and put it together again; or, if he is drawing from memory, that forces him to dredge his own mind, to discover the content of his own store of past observations. It is a platitude in the teaching of drawing that the heart of the matter lies in the specific process of looking. A line, an area of tone, is not really important because it records what you have seen, but because of what it will lead you on to see. Following up its logic in order to check its accuracy, you find confirmation or denial in the object itself or in your memory of it. Each confirmation or denial brings you closer to the object, until finally you are, as it were, inside it: the contours you have drawn no longer marking the edge of what you have seen, but the edge of what you have become. Perhaps that sounds needlessly metaphysical. Another way of putting it would be to say that each mark you make on the paper is a stepping-stone from which you proceed to the next, until you have crossed your subject as though it were a river, have put it behind you.

This is quite different from the later process of painting a 'finished' canvas or carving a statue. Here you do not

pass through your subject, but try to re-create it and house yourself in it. Each brush-mark or chisel-stroke is no longer a stepping-stone, but a stone to be fitted into a planned edifice. A drawing is an autobiographical record of one's discovery of an event - seen, remembered or imagined. A 'finished' work is an attempt to construct an event in itself. It is significant in this respect that only when the artist gained a relatively high standard of individual 'autobiographical' freedom, did drawings, as we now understand them, begin to exist. In a hieratic, anonymous tradition they are unnecessary. (I should perhaps point out here that I am talking about *working* drawings – although a working drawing need not necessarily be made for a specific project. I do not mean linear designs, illustrations, caricatures, certain portraits or graphic works which may be 'finished' productions in their own right.)

A number of technical factors often enlarge this distinction between a working drawing and a 'finished' work: the longer time needed to paint a canvas or carve a block: the larger scale of the job: the problem of simultaneously managing colour, quality of pigment, tone, texture, grain, and so on – the 'shorthand' of drawing is relatively simple and direct. But nevertheless the fundamental distinction is in the working of the artist's mind. A drawing is essentially a private work, related only to the artist's own needs; a 'finished' statue or canvas is essentially a public, *presented* work – related far more directly to the demands of communication.

It follows from this that there is an equal distinction from the point of view of the spectator. In front of a painting or statue he tends to identify himself with the subject,

Drawing

to interpret the images for their own sake; in front of a drawing he identifies himself with the artist, using the images to gain the conscious experience of seeing as though through the artist's own eyes.

THE EXPERIENCE OF DRAWING

As I looked down at the clean page in my sketch-book I was more conscious of its height than its breadth. The top and bottom edges were the critical ones, for between them I had to re-construct the way he rose up from the floor, or, thinking in the opposite direction, the way that he was held down to the floor. The energy of the pose was primarily vertical. All the small lateral movements of the arms, the twisted neck, the leg which was not supporting his weight, were related to that vertical force, as the trailing and overhanging branches of a tree are related to the vertical shaft of the trunk. My first lines had to express that; had to make him stand like a skittle, but at the same time had to imply that, unlike a skittle, he was capable of movement, capable of re-adjusting his balance if the floor tilted, capable for a few seconds of leaping up into the air against the vertical force of gravity. This capability of movement, this irregular and temporary rather than uniform and permanent tension of his body, would have to be expressed in relation to the side edges of the paper, to the variations on either side of the straight line between the pit of his neck and the heel of his weight-bearing leg.

I looked for the variations. His left leg supported his weight and therefore the left, far side of his body was tense, either straight or angular; the near, right side was com-

paratively relaxed and flowing. Arbitrary lateral lines taken across his body ran from curves to sharp points – as streams flow from hills to sharp, compressed gulleys in the cliff-face. But of course it was not as simple as that. On his near, relaxed side his fist was clenched and the hardness of his knuckles recalled the hard line of his ribs on the other side – like a cairn on the hills recalling the cliffs.

I now began to see the white surface of the paper, on which I was going to draw, in a different way. From being a clean flat page it became an empty space. Its whiteness became an area of limitless, opaque light, possible to move through but not to see through. I knew that when I drew a line on it – or *through* it – I should have to control the line, not like the driver of a car, on one plane: but like a pilot in the air, movement in all three dimensions being possible.

Yet, when I made a mark, somewhere beneath the near ribs, the nature of the page changed again. The area of opaque light suddenly ceased to be limitless. The whole page was changed by what I had drawn just as the water in a glass tank is changed immediately you put a fish in it. It is then only the fish that you look at. The water merely becomes the condition of its life and the area in which it can swim.

Then, when I crossed the body to mark the outline of the far shoulder, yet another change occurred. It was not simply like putting another fish into the tank. The second line altered the nature of the first. Whereas before the first line had been aimless, now its meaning was fixed and made certain by the second line. Together they held down the edges of the area between them, and the area, straining

under the force which had once given the whole page the potentiality of depth, heaved itself up into a suggestion of solid form. The drawing had begun.

The third dimension, the solidity of the chair, the body, the tree, is, at least as far as our senses are concerned, the very proof of our existence. It constitutes the difference between the word and the world. As I looked at the model I marvelled at the simple fact that he *was* solid, that he occupied space, that he was more than the sum total of ten thousand visions of him from ten thousand different viewpoints. In my drawing, which was inevitably a vision from just one point of view, I hoped eventually to imply this limitless number of other facets. But now it was simply a question of building and refining forms until their tensions began to be like those I could see in the model. It would of course be easy by some mistaken over-emphasis to burst the whole thing like a balloon; or it might collapse like too-thin clay on a potter's wheel; or it might become irrevocably misshapen and lose its centre of gravity. Nevertheless, the thing was there. The infinite, opaque possibilities of the blank page had been made particular and lucid. My task now was to co-ordinate and measure: not to measure by inches as one might measure an ounce of sultanas by counting them, but to measure by rhythm, mass and displacement: to gauge distances and angles as a bird flying through a trellis of branches; to visualize the ground plan like an architect; to feel the pressure of my lines and scribbles towards the uttermost surface of the paper, as a sailor feels the slackness or tautness of his sail in order to tack close or far from the surface of the wind.

I judged the height of the ear in relation to the eyes, the

angles of the crooked triangle of the two nipples and the navel, the lateral lines of the shoulders and hips – sloping towards each other so that they would eventually meet, the relative position of the knuckles of the far hand directly above the toes of the far foot. I looked, however, not only for these linear proportions, the angles and lengths of these imaginary pieces of string stretched from one point to another, but also for the relationships of planes, of receding and advancing surfaces.

Just as looking over the haphazard roofs of an un-planned city you find identical angles of recession in the gables and dormer-windows of quite different houses – so that if you extended any particular plane through all the intermediary ones, it would eventually coincide perfectly with another; in exactly the same way you find extensions of identical planes in different parts of the body. The plane, falling away from the summit of the stomach to the groin, coincided with that which led backwards from the near knee to the sharp, outside edge of the calf. One of the gentle, inside planes, high up the thigh of the same leg, coincided with a small plane leading away and around the outline of the far pectoral muscle.

And so, as some sort of unity was shaped and the lines accumulated on the paper, I again became aware of the real tensions of the pose. But this time more subtly. It was no longer a question of just realizing the main, vertical stance. I had become involved more intimately with the figure. Even the smaller facts had acquired an urgency and I had to resist the temptation to make every line over-emphatic. I entered into the receding spaces and yielded to the oncoming forms. Also, I was correcting: drawing

over and across the earlier lines to re-establish proportions
or to find a way of expressing less obvious discoveries. I saw
that the line down the centre of the torso, from the pit of
the neck, between the nipples, over the navel and between
the legs, was like the keel of a boat, that the ribs formed a
hull and that the near, relaxed leg dragged on its forward
movement like a trailing oar. I saw that the arms hanging
either side were like the shafts of a cart, and that the out-
side curve of the weight-bearing thigh was like the ironed
rim of a wheel. I saw that the collar-bones were like the
arms of a figure on a crucifix. Yet such images, although I
have chosen them carefully, distort what I am trying to
describe. I saw and recognized quite ordinary anatomical
facts; but I also felt them physically – as if, in a sense, *my*
nervous system inhabited *his* body.

A few of the things I recognized I can describe more
directly. I noticed how at the foot of the hard, clenched
weight-bearing leg, there was clear space beneath the arch
of the instep. I noticed how subtly the straight under-wall
of the stomach elided into the attenuated, joining planes
of thigh and hip. I noticed the contrast between the hard-
ness of the elbow and the vulnerable tenderness of the
inside of the arm at the same level.

Then, quite soon, the drawing reached its point of crisis.
Which is to say that what I had drawn began to interest
me as much as what I could still discover. There is a stage
in every drawing when this happens. And I call it a point
of crisis because at that moment the success or failure of
the drawing has really been decided. One now begins to
draw according to the demands, the needs, of the drawing.
If the drawing is already in some small way true, then

these demands will probably correspond to what one might still discover by actual searching. If the drawing is basically false, they will accentuate its wrongness.

I looked at my drawing trying to see what had been distorted; which lines or scribbles of tones had lost their original and necessary emphasis, as others had surrounded them; which spontaneous gestures had evaded a problem, and which had been instinctively right. Yet even this process was only partly conscious. In some places I could clearly see that a passage was clumsy and needed checking; in others, I allowed my pencil to hover around – rather like the stick of a water-diviner. One form would pull, forcing the pencil to make a scribble of tone which could re-emphasize its recession; another would jab the pencil into re-stressing a line which could bring it further forward.

Now when I looked at the model to check a form, I looked in a different way. I looked, as it were, with more connivance: to find only what I wanted to find.

Then the end. Simultaneously ambition and disillusion. Even as in my mind's eye I saw my drawing and the actual man coincide – so that, for a moment, he was no longer a man posing but an inhabitant of my half-created world, a unique expression of my experience, even as I saw this in my mind's eye, I saw in fact how inadequate, fragmentary, clumsy my small drawing was.

I turned over the page and began another drawing, starting from where the last one had left off. A man standing, his weight rather more on one leg than the other. . . .

The difficulty of being an artist

During the last thirty years, and particularly during the last decade, it has been, I believe, particularly difficult to be a good artist. If we marvel now at the cultural vitality of the first quarter of this century, this is not necessarily nostalgia. It was easier for Picasso's generation.

Of course it is always, always very difficult.

He who has not felt the difficulties of his art does nothing that counts; he, who like my son, has felt them too soon, does nothing at all; and you can be sure that most of the high conditions of society would be empty if one were admitted only after an examination as severe as the one we must pass.

Chardin's remark is true for all generations. And since Chardin, the artist's struggle to live, as distinct from his struggle to master his art, has also become harder. Yet the financial and social difficulties of the artist today are no greater than they were eighty or forty years ago. The artist's supreme difficulty today is of a different kind.

Jimmy Porter's famous speech about there being no good causes left to fight for has a good deal to do with this difficulty. The speech, of course, is - and perhaps was meant to be - short-sighted, self-pitying, and objectively untrue. But it does demonstrate crudely and in one phrase the kind of disillusion on which most post-war art in Europe has been based. Men such as Camus, Malraux, Beckett, Giacometti, Marini, Buffet, may all be more

subtle and complex than Jimmy Porter, but all of them have produced works of qualified disillusion and despair. (Consider, as an example of the extent of this state of mind, how seldom even sex has been treated as a subject of affirmation or pleasure in the post-war arts.) Increasingly, during the last twenty-five years Europe has been politically and psychologically on the defensive. When – except during the war years when the hope of victory inspired us – have we had a *confident* vision of the future – as quite obviously artists, scientists and thinkers did have before the advent of Fascism and neo-Fascism?

One of the worst consequences of this defensiveness is triviality. Without any sense of the future one lacks a sense of perspective, and without perspective one is constantly forced into attitudes and theories of trivial opportunism. The history of anti-Communism vividly bears this out. Such triviality is also parochial. Far fewer people in Europe today have an approximate idea of what is happening on a world scale than sixty years ago.

How does this affect the artist? The artist sets out to improve the world – not in the way that a reformer or a revolutionary does – but in his own way, by extending what he believes to be the truth, and by expressing the range and depth of human hopes. In a climate of disillusion it becomes very difficult for him to desire or believe in even his kind of improvement. As a result, his art also becomes trivial; he begins to mistake the means for the end.

It is the triviality of so many contemporary works, not the small number of people who look at or read them, that makes them so irrelevant to the modern world. In such works all purpose is reduced to its minimum. A Tachist

painting looks like one square centimetre of an Impressionist painting blown up to fill twelve square feet: the average piece of 'iron' sculpture looks like the bare armature of a work that has been destroyed by fire: a piece of *L'Art Autre* looks like a bit of wood or plaster that has crumbled, been splashed with colour and thrown away. The artist, in other words, has been forced to his knees, and there tries to find significance in the scraps around him on the floor. Although it would be a mistake to make a rigid formula out of this, the thinness, spikiness, and broken, fragmentary nature of most forms in post-war painting and sculpture surely reflect the failure of nerve that I am discussing.

A full study of this reduction (yes, to absurdity) of the scale of the artist's hopes, and therefore aims, requires a thesis to itself. But without going to such lengths, one can define the particular difficulty which the western artist faces today: it is the difficulty of seeing men – including himself - whole again: the difficulty of recognizing what all men have in common, and of having confidence in what they wish to be. This is even the difficulty for a landscape painter. To paint well an artist needs a sense of space that is either secure or meaningfully dramatic, a sense of air which promises life, a sense of touch which confirms, and, above all, a sense of unending possibility, for it is only this last which can make him marvel – in delight or horror – at what actually exists.

THE MYTH OF THE ARTIST

Separate the idea of fire from the fact of fuel, and you are

left with a miracle: the focal point for a hundred and one superstitions. If you separate a modern artist's life from his work, you are left with the same kind of focal point. He retains his greatness because he retains his name, but what his greatness now invests with false significance is his loneliness, his temperament, his separation from other people, his personal tragedies. Thus, the story of his life becomes a consolation to all those who feel insecure and misunderstood. Under capitalism, which, whatever its degree of temporary prosperity, encourages social fragmentation and a sense of insecurity, one would consequently expect to find an abundance of romanticized artists' lives. And one does. The artist leading to the outsider leading to the criminal becomes the hero of societies unable to see a way out of the frustrations they inevitably encourage. A typical art critic, defending an artist of whom he has a high opinion, writes approvingly that now 'the private neurosis has acquired a cosmic stature'.

No artist's life lends itself better to this new kind of romanticism than Van Gogh's. Everyone remembers that he cut off his ear. Few know that he said: 'The cart one draws must be useful to people whom one does not know'; and that he dedicated his life to trying to make this true.

Lust for Life, the film about Van Gogh directed by Vincente Minnelli, is interesting precisely in so far as it unconsciously reveals this need to exploit the artist's unhappiness. I say 'unconsciously reveals' because this film is not just a sensational catch-dollar affair, but has obviously been made with a conscious respect towards its subject. There are quotations from Van Gogh's letters. We see many of his actual paintings close up in Metrocolor.

The difficulty of being an artist

Everything that can be reconstructed – on the circumstantial level – is reconstructed. The make-up artists have done wonders. We see the yellow house at Arles, the famous bedroom, Roulin the postman, the Young Man, Dr Gachet, and so literally are they all reproduced that, for instance, we never see Dr Gachet without the white cap in which he was painted!

But among these accurate sets and behind these life-like masks, what fills and animates and ruins the film is the vision of Van Gogh as a victim: not the victim of his ruthless determination to work: not the victim of Dutch Calvinism: not even the victim of poverty; but the victim of some strange impersonal fate expressing itself in what is presented as his lunacy.

And here, in case the reader considers that I am taking one naive film too seriously, I must emphasize that the attitude behind it is typical, and that in fact it is not so naive. In *Moulin Rouge* a very similar view was taken of Toulouse-Lautrec. We have seen the same in versions of the lives of Gauguin, Rimbaud, Rembrandt.

It is of course true that Van Gogh was subject to violent attacks of something approaching insanity, but his greatness and his heroic achievement were the result of his making this *incidental* to his life work. In this film it is made the only theme, the only source of drama. As I have said, we see many of his paintings and we sometimes see him at an easel. But there is no suggestion that his work supplied the only rhythm his life had.

The symbol of St Luke, the patron saint of painters, is as you know an ox. Thus one must be as patient as an ox if one would wish to cultivate the field of art.

35

It would not have been difficult to convey such an attitude and practice filmically. Instead we witness a few paroxysms of work closely linked with wild fits of madness. The same attempt to separate what an artist *is* from what he *does* also makes all the other painters in the film absurdly unconvincing. They all become charlatans, which is what they would have been had they not worked. Seurat becomes a car salesman selling a theory, Pissarro a kind of studio Polonius, Gauguin a GI turned St Germain.

And just as Van Gogh's temperament is separated from his work so is it also separated from his social environment. Except for his brother Theo who, until the death-bed scene, appears to be only an infinitely patient probation officer, everyone else joins the ranks of the Other People. Vincent's father, his sister, the missionary preachers, the miners, the potato-eaters, the prostitute he lives with, the people of Arles, all misunderstand him as a romantic matter of course. There is not a hint that in many cases he was misunderstood because he saw as clearly as Dickens or Zola the hypocritical contradictions of his society and refused to accept them.

> When one is released after having spent a long time in a prison there are moments in which one yearns for the walls of the cell again simply because one is no longer quite at home in a state of freedom – probably so-called owing to the fact that the exhausting hunt after daily bread does not leave one a moment of liberty.

It is typical of the film that one sees Van Gogh not being able to pay for his drinks after a night bout, but that one never sees him being unable to pay for his food. Even his poverty becomes part of his temperament, so the fact that,

at times, he quite simply starved, or the fact that he was always suffering guilt about his dependence on his brother, become too ordinary to be relevant.

So far I have described what the film does not do; but what it does do, in presenting Van Gogh's temperament, underlines even more strongly, I think, the artist-outsider-criminal theme of consolation. His character is split into two quite separate halves. On one hand he is a chap just like us having a spot of trouble with a few 'psychological adjustments'. In this role he is a Billy Graham manqué as a missionary: he is a bit rude to his father about God: he uses the wrong technique in courting his cousin: he loves Dutch cookies; and on his death-bed he wants to go home. On the other hand he is the victim of his fate: his insanity descends on him like the mistral on Provence. And in this role he is the notorious hunted man with every hand against him: when the attacks come, Kirk Douglas screws up his face like a man with a bullet in his stomach: when he quarrels with Gauguin he spreadeagles himself against the door: when he chases Gauguin with a razor, the back streets of Arles are made to look like the inevitable tunnel: when he collapses he still grasps the tube of ochre which continues to emit its pigment.

It is important, however, to emphasize why I pick on this typical film. It is not from the point of view of a specialist scholar. A dramatized life is bound to distort: the point is how it distorts. Legends are not histories, and Van Gogh's life is certainly the stuff of legend: it is like the flight of an arrow. But the function of the legendary hero is to inspire the legend's public, who want to continue in spirit from where the hero leaves off. And the perversity

of this legend is that the hero has been made in the image of our most destructive and anti-social fantasies. I am not criticizing from an exclusive vantage point. On the contrary, I am criticizing from the simplest and most human position – trying to relate the heroic example of Van Gogh's life to the lives of large film audiences.

Lust for Life is a Portrait of the Artist at Bay. But no artist, or man, can entirely be that and remain an artist, or a man. Van Gogh was the genius he was, not because he could see no way out, but because he could write:

> I admire the bull, the eagle and man with such an intense adoration, that it will certainly prevent me from ever becoming an ambitious person.

THE GALLERIES

Two dealers are talking with that air of distinguished boredom which comes from long hours of staring vacantly at works of art.

'Finally we let it go for £2,500. But on the whole it's been very quiet these last two months.'

'The weather?'

'Maybe. Or the election.'

A few hundred yards away inside the Beaux Arts Gallery there is a room full of paintings and drawings by a young artist. One has the impression of a talented student (his drawings are serious and searching) who doesn't yet know what to do and so turns his indecision into a mannerism. It is a pity that he has not waited longer before exhibiting, but the poetry lover with her hair in plaits around her head says, 'I feel he's got something of his own, you know.'

The difficulty of being an artist

Upstairs in the same gallery a stout critic, in front of some highly coloured decorative but tortured works by a young London Primitive, is declaring that 'It would be interesting to know whether he's seen the early Klees or whether he's only looked at cheap cinema decoration.' What *would* be interesting to know is whether this artist, given the chance, could produce good textile designs. If he could it would be a solution to some of the difficulties of his life.

At the Lefevre visitors stand impassive before some bitter new gouaches.

'Well of course Goya did it better,' says a Burlington Arcadian with a rolled umbrella.

'Or shall we say differently?' replies a flowered waist-coat.

At the other end of the Gallery, two women from Croydon with a Pekinese between them stare at a picture of dead skates, whose stomachs face the spectators, and which is called Fish Women – one of the real women whispers to the other, 'I know my husband would just love this one.' But the other ignores her remark and asks

'Do you think they're all painted by the same man?'

At the Piccadilly Gallery in Cork Street there are the works of another young painter. He has not yet discovered what he wants to say, how he wants to use his visual medium, and so he pre-fabricates his pictures, distorting perspective a little there for a decorative effect, faithfully copying tones in another passage, using line drawing in another. No one in their senses would blame any student for cautiously experimenting like this. But a one-man show distorts the significance of apprenticeship. 'Art's only art

when it works as art,' says the theoretician with a beard.

An African painter is showing in the inner room of the same gallery. He uses local colour and draws the scenes exactly as they are pictured in his memory – the silhouette of the foliage of the trees against the sky like ink-blots, the tall straight figures of the men leaning to their particular tasks as though yielding to the wind, the vivid evening colours of the flowers. An apologist trying to interest a buyer says, 'This is the only one that can really claim to have pastel colours.'

The foreword to the show at Roland Browse and Delbanco states that 'Harlequin and doll are actors in a play which is the poetic equivalent of an otherwise chaotic world.' A middle-aged aesthete, however, is telling a young fellow that 'If you only study the colours and tones you'll see that, underneath, these pictures are wonderfully abstract.'

Upstairs are a few fine Modigliani pencil sketches. 'What made Modigliani such a great artist was his sense of the asymmetrical. It was this that prevented him being sentimental. Have you seen the Hiroshima panels by the way? There's real sentimentality for you.'

When I arrive home, there is a letter for me from a very mature and talented painter. In his PS he writes, 'I work eighteen hours daily – though most of it goes into teaching which is maddening. Results (in terms of finished paintings) are lamentable, and I long for a steady uninterrupted spell. I might have been a good painter!'

The difficulty of being an artist

'To be frank, cultivated people are no fonder of art than the Philistines, but they like to get thrills,' wrote Clive Bell in 1914. This is now so obviously true that the very word Philistine has become curiously old-fashioned; the distinction it suggests no longer seems valid – the more so because we now realize that the Philistines also like thrills, only of a different type. There is little real difference between the intrigued Managerial wife at the Royal Academy saying, 'Just look at that beautiful material,' and the intrigued girl in jeans at the ICA saying, 'These textures are absolutely the most exciting I have ever seen in my life.'

This should not lead one to the conclusion that the Academy is as likely as any other institution to become a centre of serious art. Modern work may filter in. I say 'modern' for that is the conventional distinction used at Burlington House.

But – and this is the point – it is not for the few dozen self-respecting paintings that the sales at the Academy are higher than at any comparable exhibition – nor is it for them that the Royal Academy continues to be one of the Social Occasions of the year, its opening speeches broadcast, and its reviews filling columns in the popular press. The Academy will only change its essential character as our culture as a whole changes. Consequently, what is significant about the Academy is not its lack of art, but the type of thrill which it offers. If every picture tells a story, the Royal Academy records a history. Because visual images are more direct and often more ingenious than

41

literary ones, the Summer Exhibition reveals, year by year, the taste, the mythology of our middle and upper classes more vividly than any other public institution or display. If I wanted to show a foreigner the established heart of England, I would take him to Burlington House.

What makes this heart beat is, I believe, changing. Naturally many of the pictures on show might have been exhibited at any time during the last twenty years. There are still the traditional family jokes – a painting, for example, of a monkey sitting on a pile of books which is called *The Seat of Learning*. Yet since the war a new trend has become more and more obvious. The most typical and fashionable pictures no longer illustrate the respectability of the domestic virtues, or the dignified responsibility of the white man's burden, but the values of publicity glamour. Previously Academic painting tried to express moral principles in terms of superficial appearances. Now superficial appearances are becoming all-important for their own sake. The ultimate standard is beginning to be 'attraction' regardless of any other issue.

All bad painting is sentimental. But when one compares present academic painting with Victorian or Soviet art one sees the different nature of their sentimentality. The worst of Victorian painting sentimentalized spiritual yearning; the worst of Soviet painting sentimentalizes the achievements of labour; we, at our worst, sentimentalize cheese-cake. A virgin, a Stakhanovite, a mannequin – these are the different heroines.

Schoolgirls in the garden are now painted in the same spirit as their elder sisters whom we see in more sophisticated circumstances – *Françoise se lève*. The wives of

notable men smile reassuringly at us, as though at themselves in their dressing-table mirrors after they have put the last touch to their make-up. In a room furnished like an Espresso bar with hygienic rays of sunlight coming in through the window, a nude girl is putting on a transparent slip. What makes a work like this almost pornographic is its destruction of all intimacy and its lack of all passion. Here, as it were, is a Susannah and the Elders in which the Elders are all fashion magazine photographers and Susannah knows it only too well.

The Academy confirms other signs that the expensive window dressing of sex is the new hallmark of social distinction – the equivalent of a dowry. Whereas fifty years ago the desirable young woman would have been depicted invitingly pure in the rose garden, and thirty years ago aggressively fast sitting on the edge of a table, she is now shown passively, elegantly and shamelessly having her bodice pinned up at a couturier's. The acclaim given Annigoni's portrait of the Queen reveals how deeply this new mythology has been accepted. It is a badly composed, weakly drawn, grubbily painted picture, totally lacking in grandeur. But it has glamour. It is the nearest that, with respect, we can get to a Royal pin-up.

In the male portraits one finds the masculine equivalent of the same quality. The directors and executives fold their hands on their desks and smile like the men in shaving lotion advertisements – white handkerchiefs always in their breast pockets for their crocodile tears.

That most Academy works arrange the world to fit illusions like these, obviously explains their sentimentality. What may not be so clear is that it equally explains their

pretty photographic naturalism. If you want to deceive, the best way to do it is to quote arbitrarily chosen statistics. A lie must always be made to seem more probable than the truth. These pictures must make up in superficial conviction what they lack in real conviction. It also largely explains their incompetence. If an artist is to deceive, he cannot afford to search; all searching discoveries by which an artist can develop his vision seem at first improbable, implausible. And anyway, behind the public smile is the jaw; and the jaw, if properly realized, will imply the possibility of other, grimmer expressions. Titian could give his sitters dignity *and* be profound because at that time a much greater proportion of daily experience confirmed that dignity; in the same way Chardin could celebrate the domestic virtues because then the domestic virtues were really believed in and not just paid lip service to.

One could put this another way. There are always some pictures in the Academy which aim at something less dishonest; a few still-lifes, a few franker portraits, some street scenes. Some of these are almost as superficial as the rest. But – and this is the point – one could say to the artists who painted them that, if they looked more searchingly, selected with more discrimination, drew better, asked themselves more thoroughly and exactly what they thought was important about their subjects, they might produce worthwhile works the essential character of which would still be the same. One could not tell the others this. If their works were better, they would be more truthful and so would defeat their purpose and change their character. They serve their function perfectly as they are.

The difficulty of being an artist

The difference between the Old (Royal) Academy and the New Academy of Formalism is that the Old Academy avoids facing up to what is happening in the world by naively imposing outdated conventions upon it; whilst the New, more sophisticated, Academy contracts out more subtly by claiming to create a world beyond the actual one: a world of subjective projections and abstractions. They are both academic in the fully derogatory sense of the word because both, cut off from any direct continuous exploration of reality, inevitably degenerate into tricks and formulae to deceive their public. On one hand, highlights on curls, conveniently smudged features, or (as in Munnings) identical brush strokes on every horse's haunches; and on the other hand, pseudo-cubist triangles, 'interesting' textures, 'Primitive' distortions, fashionable dribbles. The fight between the Academies is meaningless. They are complementary. The serious artists of our time will somehow struggle through between them.

THE BIENNALE

The largest part of the international exhibition of the Venice Biennale is organized by an Italian committee. This year (1958) this committee has been much criticized for its very obvious bias towards abstract art, and has been accused of provincialism. Lionello Venturi, the art historian and grand old man of Italian criticism, has leapt to its defence by stating that the best artists of the last sixty years have been abstract, and that anyway the pavilions organised by other countries show the same bias – the implication being that they can't all be wrong. But

45

the truth is that they can be and are. The satirists are justified in calling this Biennale *The Banale*.

Let us be clear about the issues involved. (It is worth it because in this exhibition one can read the political future of the world; it may lack masterpieces but it is full of unconscious revelations and portents.) It is not – and never has been – a question of all abstract art being fundamentally opposed to figurative art. No student of twentieth-century European culture can reasonably deny that certain abstract artists have contributed to the development of painting, sculpture and architecture. The division now is between those artists who have a sense of responsibility and those who have not; or, to put it another way, between those artists whose view of life can sustain a minimum faith in the value of human exchange, and those whom alienation has made pathological. Abstract art has long since ceased to be an affair of pure 'aesthetics'. The ivory tower has now become the padded cell – which implies 'provincialism' carried to its absolute extreme.

Thousands of works now at Venice – works from the USA, Germany, Italy, Holland, France – have one image in common: the image of muck, of garbage. Nor am I making a judgment when I say that: I am being literal. One walks from gallery to gallery to look at the forms of decay and the dirt of putrefaction. Some canvases have open holes torn in them, others have gauze stuffed into sheir gashes, others are overlaid with cement, others contist of nothing but one thick coating of the same colour which has been artificially made to crack and peel. Again, however, one must protest tolerance in order to make credible the absolute decadence of the phenomenon one

is discussing. There is no reason why painters should not use new materials and 'play' with the surface of their pictures; Braque in some of his most beautiful still lifes mixed sand with his pigment. But we are now discussing something in a completely different category. We are discussing not additions but violations. And if one single proof of the hopeless, indulgent decadence of these works is needed, it lies in the fact that quite obviously the vast majority of them will not – physically – endure for more than a couple of years. They are not objects that have been made, they are objects that have been used – like cigarette butts, broken bottles or – most suitably of all – old contraceptives.

I have on other occasions tried to explain the social and psychological factors which have made this kind of non-art possible. It does, of course, reflect unconsciously, and entirely passively, a reality: the reality of the fears, the cynicism, the human alienations that are accompanying the death throes of imperialism. It reflects, passively, the reality of our own Mau Mau superstitions, rituals and crimes – a reality against which the African Mau Mau was only a counter-measure. Yet we cannot, with complacent satisfaction, leave the argument there: partly because the West is not truly represented by its imperialism – there are also all the opposition movements; and partly because this non-art is now being exported. The Spanish pavilion is almost entirely devoted to it, and it is beginning to appear in the Polish and Yugoslav pavilions. It is exportable because it appeals to that destructive egotism which every artist has to face as a temptation within himself; it gives the sacred value of art to his smallest gesture - even to the

imprint of his thumb – and to the most petty of his ideas.

This pettiness, this poverty and 'thinness' of ideas and aims is the most striking characteristic of the present cultural atmosphere of the West, even where the final decline into non-art has not taken place. Even in the galleries where abstract art still has a certain decorative function or where the works are still figurative, one has the impression that each artist has desperately searched for some little novelty of his own and then been content to mass-produce it and market it. The most extreme example of this gimmick mentality is a painting which simply consists of the Stars and Stripes as they appear on the American flag. A more serious and therefore tragic example is that of the highly talented English sculptor, Kenneth Armitage. He has hit upon the idea of making the torsos of his figures look like table tops, so that the legs and arms stick out like the limbs of a man in the stocks. Certainly it has a surprise value which generates a super- ficial emotion. But after a while one thinks: if only this man could use his talent, if only he was free, if only he wasn't compelled to turn out gimmicks! Yet who compels him?

There is the irony. For the art of the self-styled Free World is quickly becoming the most cramped and limited art ever produced. By comparison the Soviet pavilion, which is full of old-style Stalinist works, is rich and various and ingenious. Admittedly the richness is literary, and visually the Russian paintings are very sentimental; admittedly they are painted with clichés distributed by bureaucrats. But if one has to choose between the un- imaginativeness of bureaucrats and the fantasies of the sick. . . . ?

The difficulty of being an artist

In fact, for questions of art, one does not have to make that choice. Among the 500 or so artists on show at Venice there are perhaps a dozen who were possibly born with no more talent than their fellow exhibitors but who encouragingly remind us that art is independent to exactly the same degree as it discloses reality. There are Kewal Soni, Indian sculptor; Padamsee, Indian painter; Ivan Peries, Ceylonese painter; Raul Anguiano, Mexican follower of Rivera; Brusselmans of Belgium; Ichiro Fukuzawa, Japanese expressionist. And then there is the pavilion of the United Arab Republic. Only occasionally do history and art correspond with one another as directly as they do here; but it remains a fact that this pavilion is the most affirmative and vital of all in the 1958 Biennale. I do not, of course, mean that geniuses have appeared overnight in Cairo. What makes these works outstanding is that they affirm. They are not defensive treaties. Men come before things. Their language is largely traditional. Its sun-dyed colours, its expressive use of decorative silhouettes and its easy and unselfconscious simplifications derive from traditional Egyptian art and design. Yet it is the art of the West that appears by contrast not only to be academic but also, in the context of the emerging twentieth-century world, finished, exhausted, outlived.

THE GLUT

Most of the galleries have opened their mixed summer exhibitions. Several hundred contemporary British artists must now have works on show. Ten times as many artists in London alone must either have decided not to exhibit

or been unable to do so. Perhaps a quarter – but probably less – of those who are exhibiting will sell one or two works. This sort of argument usually leads to a plea for more extensive patronage. But what is seldom realized is that even under the best conditions the present number of independent, so-called Fine Artists would be excessive.

Looking round the mixed exhibitions themselves one realizes the same thing in a different way. In front of picture after picture one asks why is this person a professional artist, why did he paint this picture? And one asks this, not necessarily because the works are incompetent or tasteless – often they are extremely skilful and 'sensitive' – but because they lack even the minimum of urgency or compulsion, because their artists clearly haven't the essential creative imagination to have anything to say. Many of them might be excellent craftsmen if they were working under another artist's direction – but that is a different question.

It is a commonplace that our society has turned the artist into something between a spiv, a funny eccentric and a holy hermit in the desert. But the important point is that such a status attracts people; it does not repel them. Thousands who are disgusted, bored or frustrated, consciously or unconsciously, by the motive force of our society, find a justification for their vaguely rebellious feelings by trying to become 'outcast' artists. Denied a sense of the future or any likelihood of recognized personal responsibility, they embrace Art which they believe to be 'timeless' and which, according to current aesthetic standards, makes all responsibility supremely and entirely personal. One could put this another way round by saying that if every artist in the

country was legally bound tomorrow to be paid a regular salary for doing a regular job, the number of those who would want to be professional artists would actually decrease.

From this state of affairs one can draw two conclusions. The first is that no real answer to the question of patronage is possible so long as it continues to be considered an isolated problem by itself. And the second is that for the present the soundest if rough criterion by which we can judge which artists deserve such patronage as exists, is whether or not their work bears the mark of a hard struggle to communicate some objective discovery. The majority who have been wrongly driven into art for its romantic consolations, inevitably delight either in formal, technical perfection for its own sake or in subjective chaos. Both such types of work lack imagination, for imagination is not, as is sometimes thought, the ability to invent; it is the capacity to disclose that which exists. Only those who have become artists, despite the present status of the artist, will have the will to do this.

THE PLIGHT OF THE STUDENT

The position of the art student today is almost untenable, both logically and practically. Certainly thousands of art students exist, but this is largely the result of the ingenuity, buoyancy, determination or pig-headedness of youth. Their position is logically untenable because they are being trained – nominally at least – to be painters and sculptors for whose work there doesn't begin to be any adequate demand. Their position is often almost untenable

practically because the grants awarded to them for their period of study are insufficient. There are many students who do not get enough to eat. Not long ago I knew a painting student who was working in a cellar without electric light and with only a two-foot square pavement grid in the ceiling. During the holidays (when they are meant to be studying on their own) one finds students bottle-washing, portering or serving in cafés. Romantics will claim, of course, that such is the traditional and appropriate lot of students. Yet even if one admits this, there are other equally overwhelming if more subtle forms of frustration.

There is the tragic farce of students being automatically encouraged to equip themselves to teach simply because teaching is the most obvious way of their earning their living and retaining a maximum of spare time for their 'work' – seldom because they have a vocation for it. Thus, a few fortunate students have the prospect of going to Art Schools to teach painters to teach painters to teach! The less fortunate ones – because children are more tiring – have the prospect of going to secondary schools. There is the growing domination in most art schools of the Ministry of Education examinations, which yield nothing, because on one hand they don't demand enough discipline and, on the other, they are inhibitingly unimaginative. And finally, there is the way art students are taught. Because every tradition has broken down, students are presented with the work of half a dozen civilizations and then told to get on with it. Various teachers can pass on various methods or demonstrate their own personal *ad hoc* solutions, but very seldom is any consistent line of purpose

or development established in a school. As a result, students can neither conform nor rebel. The majority simply flounder and their flounderings are called 'experiments'.

An incidental confirmation of this unreality of the student's position is the great increase of public competitions, criticism and exhibitions of students' work. Students are no longer even considered students; they are considered 'young artists'.

BEYOND BOND STREET

Mr Griffiths is nearly seventy-five years old. But his agility and his totally unembittered eyes, curious and interested behind his shiny glasses, make him seem very much younger. In 1907 – or was it 1909? – he had digs in Chelsea. It is from then that he dates his interest in fungi. They grew through the roof of the attic. Yesterday, as honorary secretary of the Community Association, he was helping to hang the Art Exhibition in the Town Hall, a small building in the triangular market place. He had the benign, slightly fussed air of an uncle putting the last touches to the preparations for a party.

Just after the war the Town Hall was going to be pulled down in the interests of a Road Improvement scheme. But, thanks to the economy cuts, it wasn't. 'Of course,' Mr Griffiths was saying, 'we put on a deal at a lower level. Behind the scenes I'm behind our Variety show. They flock to see it and that means that we can also afford to have two Arts Council concerts a year. We only lose about £15 on each. The swings and the roundabouts, you know.' Mr Griffiths himself plays the viola.

Permanent Red

The pictures were of all sorts. There was the work of a local professional landscapist: pastels of the mountains as clean and smooth as though painted with enamel on copper. There were Tudor cottages as black and white as chessboards. There was a loving picture of *The Lake of Love at Bruges* (Not for Sale). There was a Tragic work by a schoolboy – with a symbolically broken pillar – of Napoleon on Elba. There were enough flowers for a marriage. There was the work of the local art students. 'I was thinking this morning,' Mr Griffiths said, 'of all the different tricks they have for all the different kinds of trees.' There was a portrait of Ernie, the town's darts champion. Ernie, who invariably wears a black cap, also has a prize white walrus moustache. He must be about seventy, and he has a sweetheart of the same age. One can often see them in the evening walking through the town hand in hand. There were Wilson Steers by the art master and some woodcuts by the mistress. There was a study of sunlight on clouds as full of praise to God as a hymn in a chapel. There was a portrait of a girl with beautifully curled hair that reminded me of the late Mr Williams, barber. Mr Williams, sometimes known as the most artful man in the forest and sometimes as the richest, was describing the fate of one of his colleagues: 'And then he married a lady hairdresser – you know the sort: the sort that just curls up and dies.' There was a painting of a cat which, as the principal of the Art School rightly pointed out, looked like a William Gear if you took the head away – it was a striped tabby. There were two curious pictures of some flowers in vases which were crammed with all the classic schizophrenic symptoms, including the made-up

54

letters. The painter, though, is a very gentle and quiet man. There were woods, glades, glens, dales, meadows, castles, wild flowers, schoolchildren, ballet dancers, sunsets and – a prophet.

The prophet in a red robe stood in the bottom left-hand corner of a painting of a great panoramic golden plain – the fields like honey sandwiches laid out on a huge plate. Above in the sky was a large sun, each one of its rays like a plank one might walk up. The picture, nailed to four slats of wood, also painted gold, was called *Until the Day Break*. The painter earns his living in the building trade. Not knowing him personally, I am not sure whether he wants a great P for Primitive plastered on his back, whether he wants to be 'taken up', compared to Wallis the fisherman painter in Cornwall, and perhaps have his work published by L—— H——s. As a schoolboy he was sickly, missed lessons, and so, when he did turn up, was told to go and draw something. It was when he started plumbing that Mr Griffiths taught him to read. He was persuaded to go to evening classes at an art school and there they proposed that he should learn lettering. Later he bought a horse to keep himself company and also an encyclopaedia to learn all about horses. Now he paints three or four pictures a year: their subjects often from the scriptures, their light visionary.

The show will be open for a week, the entrance fee is 6d, and about 500 people will visit it. I doubt whether any of them will buy *Until the Day Break* – though some may admire the cows, one to a field because no more would fit in. Mr Griffiths, however, will remain benignly, protectively, properly appreciative of his one-time pupil.

Permanent Red

Is what I've written a fair description of a small town amateur art show? Am I idealizing it? Yes, deliberately. Am I evading all problems of assessment and standard? Yes, again deliberately. Of course there is bickering and snobbery. Of course, the vast majority of the works are, judged by the standards of the capital museums of Europe, banal, sloppy, trite, boring and unoriginal. Of course Mr Griffiths' outlook is parochial if at his age he is prepared to spend whole days hanging indifferent pictures in a dingy upper room in a town whose importance declines every year. But the majority of these works are no more sentimental or unoriginal than the majority of contemporary works in the Biennale at Venice. Nor is Mr Griffiths any more parochial than those who officiate there, doing less work with a hundred times more self-importance. Conventional sentimentality is immediately recognizable; unconventional sentimentality is not, but when seen for what it is, it is often more perverse – it is healthier to be sentimental about babies than about skeletons. Sentimentality is a way of evading relevant facts. Hollyhock cottages evade no more than Francis Bacon's screams. As for the issue of narrowness and parochialism, 500 of the 3,000 inhabitants of this town will go to this exhibition and enjoy it. Is anything like that proportion of the city population interested in the Biennale? Would anything like that proportion visit the Biennale even if it only cost them 6d?

The hard cleavage between highbrow culture and middle (or low) brow culture often leads people to think of them as being totally opposed in character. In fact this is not always so. Barrie and Christopher Fry, for instance,

use very different vocabularies of experience, but the nature of their conclusions is very similar. A fire-tong piece of sculpture, photographed as such works often are against the sea, raises – and disappoints – the same sort of sense of 'mystery' as a watercolour of the sun setting behind St Michael's Mount. Some enjoy the abstraction of stereo-typed glamour: others the glamour of abstraction. You can daydream with pin-ups or – to use Malevich's phrase – you can daydream in 'the desert of non-objective feeling'. Reality and truth are outside the scope of both.

Yet if this is so, if our highbrow culture and our 'popu-lar' culture are often the reverse sides of the same coin, why do I condemn the Biennale and champion the local art show? In the name of Folk Art? In the name of Popular Art? No, for neither exists. The works in the Town Hall are in idiom as metropolitan as those in the Royal Academy, and in personality they are predominantly middle-class. I champion it for the sake of what I tried to imply at the beginning of this article – its human context. The works there, despite both their faults and their virtues, will form a nucleus for associations, reminiscences, arguments, stories, history, to nearly all those who climb the stairs to see them. Mr Griffiths did not believe he was hanging masterpieces. He was content simply to be hanging his own district's art show. Until we have achieved that spirit – not in terms of so many small towns – but in terms of an entire people, art will generally remain a luxury. And we shall not achieve it by 'education', by discovering Primi-tives or by lectures on art appreciation. We shall only achieve it by a revolutionary change in our whole society.

Artists defeated by the difficulties

NAUM GABO

Naum Gabo's new eighty-foot-high monument in Rotterdam must be among the largest pieces of modern sculpture in the world. It was made, under the artist's supervision, by Dutch shipbuilders. And indeed, it looks rather like the skeleton of a ship's prow pointed at the sky – a space ship? It consists of four golden steel and transparent plastic members which soar eighty feet upwards from the four corners of the black plinth. As they go upwards they twist on themselves and turn through ninety degrees, so that the space they frame is – very roughly – like a boat, or a pointed seed pod. In the bottom half of this space is another construction of black steel branches, this time connected by membranes of thread. Like all Gabo's modern constructions, it is an abstract work, although in the handout it is said to symbolize the Tree of Life.

Light, transparent, apparently weightless, poised to flower or launch itself, it is obviously a structure which is the result of great engineering skill and the talents of a born designer – of a man who has an intuitive understanding of the potentiality of his materials, and who can visualize any structure from every point of the compass simultaneously. In other words, it is no small feat. But is it, as Sir Herbert Read suggests, 'an image of universal beauty'?

Let us try to find a way round the sheer cliff face of

absolutes by considering in more detail the history of such sculpture. Today, Gabo, who was born in Russia sixty-eight years ago, still calls himself a Constructivist, and he made his first tentatively Constructivist works in wood in 1915. The theory on which these were based was developed during the early years of the Revolution, and was then proclaimed in the *Realistic Manifesto*, published in Moscow in 1920, and written by Gabo and his brother Antoine Pevsner.

Originally Gabo was trained as an engineer, and this gives us a clue to the nature of the theory of Constructivism. The theory is that the sculptor, instead of being concerned with the mass and surfaces of forms in nature, should reveal and make explicit their engineering and mathematical principles of construction. Thus, the Constructivist, like Pollaiulo or Signorelli, becomes a kind of anatomist, not this time in terms of bones and muscles, but in terms of the diagrammatic 'grid' of those structural forces which allow a form to take the particular shape it does. The first Constructivist works dealt with specific subjects – a head or a torso. But because the laws of statics and dynamics are universal, they quickly became general demonstrations of structural possibilities, and therefore abstract works.

As often happens, however, the theory does not in itself fully explain the ensuing works, or the spirit behind them. It is very important to understand that Constructivism was born of the revolutionary fervour and hopes of its time. Gabo says that he was politically 'neutral' during the Revolution, and had little to do with the Bolsheviks. But he believed that what was happening in 1920 was:

the blossoming of a new culture and a new civilization with their unprecedented-in-history surge of the masses towards the possession of the riches of Nature . . .

It was revolutionary expectation and hope which led the Constructivists to connect art with science (in times of despair the opposite happens), to use new materials demanding new techniques (Gabo was using plastics in 1920), to oppose the idea that art should supply a refuge for the privileged, to reject the romantic cult of the artist's personality, and above all, to think in terms of a new, rational, scientific society. The *Realistic Manifesto* ends:

> *Today is the deed.*
> *We will account for it tomorrow.*
> *The past we are leaving behind us as carrion.*
> *The future we leave to the fortune tellers.*
> *We take the present day.*

The materialism, the confidence, the sense of historical destiny implied in those words, all arise from a revolutionary spirit. But – and this is the critical point – Gabo and his friends conceived of the revolution not in terms of politics and economics, but in terms of mechanics and engineering. The fundamental idea behind Constructivism is that of the engineer as a prophet, the idea of the engineer as an independent revolutionary.

In 1922, because his art was disapproved of by the Soviet Government, Gabo left Russia for Germany. He later came to England, and now lives in the United States. The West accepted him as an artist and allowed him to build his reputation. But the social and cultural climate in which he now worked was in marked contrast to that in which Constructivism was born. His works were treated

as a new kind of *objet d'art*. His projects for electrical displays, radio stations, towers, remained projects. The Rotterdam commission was the first he received for a really large public monument. When I was in Rotterdam I met the man who commissioned him. This is what he told me.

After the war the Bijenkorf Company wanted to build a new store in the centre of the new Rotterdam. They chose the most propitious site. They then discovered that the city planners were insisting that the open corner of the proposed building must project outwards, in a small pepper-pot bay – so as to keep the street line symmetrical in relation to the one surviving old building which similarly projected out into the street. The Directors were in despair. Either they would have to sacrifice the best site in the city, or they would have to comply with the planners, and so lose the whole compelling corner perspective of their show-windows. It was then that the man whom I met told the rest of the Board to take the site whatever the conditions, and he would find a solution. He thought hard. What was the problem? There had to be a projecting structure to satisfy the planners, yet somehow this structure must not destroy the show-window perspective. Suddenly, this man, who is very interested in modern art, remembered the Constructivists. Had they not said, 'We deny volume as an expression of space . . . we reject solid mass as an element of plasticity'? A Constructivist could fill the space, and yet, 'rejecting solid mass', not hide the show-windows! And so Gabo was approached and commissioned.

I then asked this patron why the store itself – designed by Marcel Breuer – had no windows above street level,

why inside, except in the restaurant, it was entirely enclosed. The answer was as frank as the explanation about Gabo: Because we find that commodities sell better under artificial light! Is it surprising that Gabo wrote to Sir Herbert in 1944, 'I try to guard in my work the image of the morrow we left behind us in our memories and forgone aspirations, and to remind us that the image of the world can be different'? It is the West that has demonstrated how the initial faith of the Constructivists was an inadequate one. The West has great machine skill and great engineering resources, but these have not led to a rational society. A skilful architect is employed to hypnotize buyers: a brilliant designer to make a gimmick to get round a town-planning restriction.

But how does all this help us to assess Gabo's Rotterdam monument – or, for that matter, his life's work, of which in a sense it is the culmination? Fundamentally, there are only two types of man-made beauty: the beauty which expresses function, and the beauty which expresses hope – the latter being found in the impulse that is behind even a tragic work of art. The aesthete tries to separate both types of beauty from what they express, but in so far as he succeeds, he has to live in an entirely passive and contemplative world of his own, denying cause, effect, and history. Constructivism was born, as I have tried to show, in an atmosphere of specific hopes. The early Constructivist works were mostly not functional, they were sculptural images only; but the hopes they expressed were the hopes aroused by the new functional possibilities of science and engineering for an industrially backward country in a time of revolution.

Artists defeated by the difficulties

Had Gabo and other Constructivists been encouraged and supported in the Soviet Union, my guess is that their work and their attitude to it would have changed considerably. As the hopes which their works conveyed became practical and realizable, as machine products became as subtle as their own hand-made Constructions, they would probably have felt that it was logical for them to become functional designers themselves: or else they would have been moved as artists to extend and make more explicitly human the hopes they were expressing. The engineer prophets now are those who are making Sputniks.

The tragedy is that Gabo – among many other artists – decided to become an émigré. He did not understand the Revolution as a whole, and the Revolutionaries failed to understand his partial contribution. It remains a tragedy – and will do so until both parties admit it to be such. Like many émigrés, Gabo probably tended to cling to the ideas he brought with him, as though they were part of his homeland. But what finally prevented his development or evolution as an artist was, I believe, the contrast between the cultural and social atmosphere of the West, and the original spirit of Constructivism. This bitter contrast, combined with his exile, made him feel increasingly isolated. He withdrew into himself and began to shield his theories with a static form of idealism.

And so, Gabo's work, which once had a specific meaning in a particular situation, did not develop with the situation, and consequently its meaning has become vaguer and vaguer. I asked many people in Rotterdam what they thought of the monument. Most of the middle-aged did

63

not like it. Most of the young – of all classes – did, and all gave the same reason: 'It's part of the modern world.' But when I questioned them further I discovered that what they meant was that they felt about this work of art as they would feel about the most up-to-date exhibit or model in a science museum. Soon history will outstrip Gabo's technical prophecies as it can never outstrip a direct expression of human hope.

PAUL KLEE

While thinking just now, I began, without realizing it, to doodle at the top of the paper. If one compared this scribble of mine with any of the 3,500 Klee drawings that exist, it would look ugly and unremarkable. It wouldn't begin to tickle your fancy like, for instance, Klee's drawing of a boat cats-cradled from a single piece of string, with reins instead of a rudder, a match for a funnel, a pin-man as pilot, the tide like a storm in a tea-cup and the full moon like a scone in the sky. Nor would it tickle you so that, instead of laughing, you would momentarily shudder – as you might before the drawing called *History*, in which three graven images, with faces like bulldozers, smack three pin-people down on to the floor, and so much frighten a horse that one of his eyes pops out – and round – to visit the other. In one sense, therefore, the popular journalist who described Klee as 'the man who had made doodling an art' was right.

But in another sense I believe that Klee can barely be considered an artist at all. A work of art must be born of conscious intention and deliberate striving: and the spec-

tator, although he may not immediately and fully understand the work, must be able to infer this. This is the fundamental difference (in terms of one's reaction) between discovering a natural object and a man-made one: between a cliff face and a wall: between the beauty of a landscape and the beauty of a landscape painting. The reason why young children's paintings are invariably pleasing but are never works of art is that they lack this sense of outward intention and striving. A child paints simply in order to grow up; and his pictures are therefore almost *natural* objects, almost (and I don't mean this sentimentally) like flowers. The adult artist paints in order to create something outside himself, in order to add to – and to that extent alter – life. Klee spent all his energies trying to rid himself of outward intention, to cease striving and become entirely passive.

> Everything vanishes round me and good works rise from me of their own accord. My hand is entirely the implement of a distant sphere. It is not my head that functions but something else, something higher, something somewhere remote.

He described drawing as taking a walk with a line. He compared the artist to the trunk of a tree, passively allowing life to flow from the roots (Nature) to the foliage (Expression). Or to put it another way, Klee turned himself into an aquarium; his reflexes flower like anemones, his unconscious urges twist and turn like darting fishes. His works become natural specimens. Hence our curiosity, but also our total inability to be moved.

Permanent Red

In a period of cultural disintegration – such as ours in the West today – it is hard to assess the value of an individual talent. Some artists are clearly more gifted than others and people who profoundly understand their particular media ought to be able to distinguish between those who are more and those who are less gifted. Most contemporary criticism is exclusively concerned with making this distinction; on the whole, the critic today accepts the artist's aims (so long as they do not challenge his own function) and concentrates on the flair or lack of it with which they have been pursued. Yet this leaves the major question begging: how far can talent exempt an artist if he does not think beyond or question the decadence of the cultural situation to which he belongs?

Perhaps our obsession with genius, as opposed to talent, is an instinctive reaction to this problem, for the genius is by definition a man who is in some way or another larger than the situation he inherits. For the artist himself the problem is often deeply tragic; this was the question, I believe, which haunted men like Dylan Thomas and John Minton. Possibly it also haunted Jackson Pollock and may partly explain why in the last years of his life he virtually stopped painting.

Pollock was highly talented. Some may be surprised by this. We have seen the consequences of Pollock's now famous innovations – thousands of Tachiste and Action canvases crudely and arbitrarily covered and 'attacked' with paint. We have heard the legend of Pollock's way

66

of working: the canvas on the floor, the paint dripped and flung on to it from tins; the delirium of the artist's voyage into the unknown, etc. We have read the pretentious incantations written around the kind of painting he fathered. How surprising it is then to see that he was, in fact, a most fastidious, sensitive and 'charming' craftsman, with more affinities with an artist like Beardsley than with a raging iconoclast.

His best canvases are large. One stands in front of them and they fill one's field of vision: great walls of silver, pink, new gold, pale blue nebulae seen through dense skeins of swift dark or light lines. It is true that these pictures are not composed in the Renaissance sense of the term; they have no focal centre for the eye to travel towards or away from. They are designed as continuous surface patterns which are perfectly unified without the use of any obvious repeating motif. Nevertheless their colour, their consistency of gesture, the balance of their tonal weights all testify to a natural painter's talent. The same qualities also reveal that Pollock's method of working allowed him, in relation to what he wanted to do, as much control as, say, the Impressionist method allowed the Impressionists.

Pollock, then, was unusually talented and his paintings can delight the sophisticated eye. If they were turned into textile design or wall-papers they might also delight the unsophisticated eye. (It is only the sophisticated who can enjoy an isolated, single quality removed from any normal context and pursued for its own sake – in this case the quality of abstract decoration.) But can one leave the matter there?

It is impossible. Partly because his influence as a figure

standing for something more than this is now too pressing a fact to ignore, and partly because his paintings must also be seen - and were probably intended – as images. What is their content, their meaning? A well-known museum curator, whom I saw in the gallery, said 'They're *so* meaningful.' But this, of course, was an example of the way in which qualitative words are now foolishly and constantly stood on their heads as everybody commandeers the common vocabulary for their unique and personal usage. These pictures are meaningless. But the way in which they are so is significant.

Imagine a man brought up from birth in a white cell so that he has never seen anything except the growth of his own body. And then imagine that suddenly he is given some sticks and bright paints. If he were a man with an innate sense of balance and colour harmony, he would then, I think, cover the white walls of his cell as Pollock has painted his canvases. He would want to express his ideas and feelings about growth, time, energy, death, but he would lack any vocabulary of seen or remembered visual images with which to do so. He would have nothing more than the gestures he could discover through the act of applying his coloured marks to his white walls. These gestures might be passionate and frenzied but to us they could mean no more than the tragic spectacle of a deaf mute trying to talk.

I believe that Pollock imaginatively, subjectively, isolated himself almost to that extent. His paintings are like pictures painted on the inside walls of his mind. And the appeal of his work, especially to other painters, is of the same character. His work amounts to an invitation:

Artists defeated by the difficulties

Forget all, sever all, inhabit your white cell and – most ironic paradox of all – discover the universal in your self, for in a one-man world you are universal!

The constant problem for the Western artist is to find themes for his art which can connect him with his public. (And by a theme I do not mean a subject as such but the developing significance found in a subject.) At first Pollock was influenced by the Mexicans and by Picasso. He borrowed stylistically from them and was sustained by their fervour, but try as he might he could not take over their themes because they were simply not applicable to his own view of his own social and cultural situation. Finally in desperation he made his theme the impossibility of finding a theme. Having the ability to speak, he acted dumb. (Here a little like James Dean.) Given freedom and contacts, he condemned himself to solitary confinement in the white cell. Possessing memories and countless references to the outside world, he tried to lose them. And having jettisoned everything he could, he tried to preserve only his consciousness of what happened at the moment of the act of painting.

If he had not been talented this would not be clear; instead one would simply dismiss his work as incompetent, bogus, irrelevant. As it is, Jackson Pollock's talent did make his work relevant. Through it one can see the disintegration of our culture, for naturally what I have described was not a fully conscious and deliberate personal policy; it was the consequence of his living by and subscribing to all our profound illusions about such things as the role of the individual, the nature of history, the function of morality.

69

And perhaps here we have come to something like an answer to my original question. If a talented artist cannot see or think beyond the decadence of the culture to which he belongs, if the situation is as extreme as ours, his talent will only reveal negatively but unusually vividly the nature and extent of that decadence. His talent will reveal, in other words, how it itself has been wasted.

DUBUFFET

Jean Dubuffet, a middle-aged Frenchman, is now one of the names to conjure with in Western art capitals. Recently an intelligent English critic called him the greatest European painter of his generation. His works are worth thousands. Most are oil paintings, though they contain other 'matter' besides. I quote from a catalogue:

> His matter evolved very quickly, as if it flowed from a volcano with diverse chemical and mineral resources. It was enriched with cement, plaster, and many other products which it would be in vain to enumerate here, for they changed frequently and were worked with different instruments as this adventure – not unlike the geological formation of our planet – proceeded.

These enrichments make the surfaces of his pictures heavy, rough, mucky, and like those of crumbling damp walls. Scratched into these brown muddy surfaces, or painted on top of them, are images. (Incidentally, it is typical of the megalomaniac pretensions of post-war art fashion that when something looks like mud – or worse – it is compared to the geological formation of our planet.) Dubuffet's images generally represent deficient faces or gangling

bodies. Or, more accurately, they do not represent them – Dubuffet has said 'Observation destroys what it touches' – they are signs for them. In certain pictures these signs are definite, in others they are half lost in the surrounding texture. In a few cases the whole picture consists of nothing but continuous texture. The signs themselves are slightly similar to those used in child art, and at times are also reminiscent of certain surrealist images. Dubuffet is no chicken. Yet what they most obviously emulate are ordinary public *graffiti*. The wall and the scrawl.

Indeed, if you were innocent and knew nothing of the sickness of bourgeois culture, the only thing that would surprise you about these 'works' is that they are framed and hung in a reputable art gallery; on a bomb-site nobody would pick them up. But we are not innocent, and in this field nothing can surprise us any more. Not even the elegant gallery salesmen in their spotless suits, staring, fascinated, at mud. Not even Dubuffet's public and disciples persuading themselves that they can find 'cosmic' meaning in the works. Not even Georges Limbour proudly proclaiming that:

> He (Dubuffet) appeals to the imagination of the spectator, who will give to each painting the meaning he wants, according to his nature and the play of his fancy. . . . For those who like to let their imagination loose in the greatest liberty, how enchanting Dubuffet's painting is.

No, not even that, which self-evidently proves that Dubuffet communicates nothing. Nevertheless it is worthwhile analysing why a man like Dubuffet can, in all sincerity, end up in this position, and why his work has a sophisticated following. It is worth while because it shows

us one of the ways in which bourgeois culture is now bound to waste itself.

Neurosis has been defined as the result of 'unlived life'. Today the sensitive bourgeois artist is disgusted or bored by his official culture, but because he can see no way of changing it, and because, rejecting dialectics, he is unable to distinguish between its positive and negative tendencies, he is forced to deny absolutely his own sensibilities and heritage, to unlive his life in fact, and then to escape into some form of crude and false Primitivism. Other artists take to Action Painting and the cult of historically Primitive art. Dubuffet apes the inarticulate and disorientated victims of his own society – those who are driven by loneliness and frustration to draw primitively their private obsessions on public walls. The appeal of this primitivism to a sophisticated public is a double one. First, since it does not speak their own language, they can read into it whatever they like of themselves. Secondly, because it is foreign, they can pretend, whilst enjoying it, that they are something other than they are. Thus, both from the artist's and from the public's point of view, this is an art which derives from unlived life, and propagates it. It is in fact a phenomenon deriving from the same kind of unreality as the commercial pin-up, the government defence policy, and the average Academy portrait.

GERMAINE RICHIER

Ninety-nine people out of a hundred, if persuaded to look at the sculpture of the much-discussed French sculptress, the late Germaine Richier, would be disgusted. The half-

human spiders and insects, the wilfully split, broken heads, the pitted torsos and the shrunken limbs, disintegrating as though as a result of fire or leprosy, would strike them as ugly, morbid and pointless. They would either say diffidently, as they did *not* in front of the Hiroshima panels, that they didn't understand art, or they would be indignant.

If the hundredth person happened to be a sculptor himself, he would be forced to admit Richier's ability, although he might hate the use to which she has put it. He would recognize in a fairly straightforward portrait-head her sensitivity to structure and character. He would see that she can create a bird on a girl's hand which looks as if it is made out of crumpled paper and yet suggests all the bird-shy abruptness of a pipit. He would notice that the apparently shapeless limbs of *Man of the Night* – as deadening in their imagined sound as a blow with a sand-bag – are nevertheless as firm in sculptural form as limbs by Rodin.

If the hundredth person happened to be a fashionable intellectual he would talk of Kafka and Giacometti – although, in fact, Giacometti's aims are far more rational – and would admire the works for their originality, their lack of sentimentality (as he would put it) and the violent power with which they express putrefaction, torture, jungle life and the atavistic instincts. 'Richier's performance,' writes David Sylvester approvingly, 'is a way of finding out how much her victims can stand up to.'

A man called André Pieyre de Mandiargues says that there is a 'sylvan quality' to Richier's work because 'in the silence of the forest, consent is indicative of rape (coupling)

or murder (followed by disembowelling).' The gratuitous explanations in brackets are his.

Is the development from the incomprehension of the ninety-nine to the insight of the hundredth a process of corruption? The question might be difficult to answer, but because the intellectual today would deny its validity by claiming that art is outside normal moral considerations, he utterly condemns his own attitude and answers it for us.

As for the intelligent students, who might be influenced by Richier's technical, formal skill, surely they will realize that this is literally used for the destruction of art. Granted her 'sensibility', and armed with acetylene and a hammer, Richier could 'create' her images from the great statues in any museum. She expresses the hatred of art which is the result of a certain type of aesthete's sense of futility in face of the achievements of the past.

I have no wish to idealize the Simple Man. The readers of the *News of the World* are not Candides. But in a disintegrating culture the sophisticated attitude is the most likely to act as a catalyst to further disintegration. The use of the very word 'sophisticated' illustrates this. It is now used frequently as a compliment, yet even its recent dictionary meaning is *false* or *corrupted*.

Finally the work of a sculptor like Richier cannot be judged within the context of art. It can only amount to evidence in a case-history – not a personal but a social-cultural one. She represents – with great imagination – those who betray the values which they have isolated; those who, blind to the fact that the whole world is being changed by the vigour of millions determined to enjoy the advantages and rights of a technical, humanist civiliza-

tion, destroy their own because the task of distinguishing between the evil and the good in it is too great for them.

BARBARA HEPWORTH

I remember that when Barbara Hepworth's two monumental figures called *Contrapuntal Forms* arrived at the South Bank for the Festival, the workmen who unloaded them spent a long time searching for an opening or a hinge because they believed that the real figures must be inside. I do not repeat this story now to encourage all those who automatically hate contemporary art for being contemporary: but because it seems to me to point to the basic emptiness of sculpture like Miss Hepworth's – there wasn't anything inside the contrapuntal forms. What are the causes of this emptiness: an emptiness which even all the good intentions, energy, sensibility, skill and single-mindedness that may lie behind such works cannot fill?

First, at the heart of Miss Hepworth's and many other contemporary artist's and critic's ideas there is a fundamental confusion about the relationship between form and content. (Here I should emphasize that content is not the same thing as subject matter: it is what the artist discovers *in* his subject.) It is its content that makes any work of art dynamic. It is the content that the artist distils from life and which, through its influence on the spectator as he comprehends it, flows back into life. The function of the form of a work is to concentrate, to hold the pressure of both the artist's and spectator's experience of the content.

Yet that is only half the problem. Many of Miss Hep-

75

worth's works are not strictly speaking abstract. They vaguely resemble figures or natural objects and so can be said to have content of a sort. Why do these seem as empty and dead as the others? In any period that lacks a faith which is so intrinsically part of the whole culture that its symbolism can be automatically applied by everybody to every event, the content of a work of art can only derive from definite, specific, particular experience. The artist may achieve some general truth, universality; but he cannot aim at such qualities directly. They will only be achieved by the most faithful insight into what it means to be a particular person in a particular situation. Every great work since the High Renaissance proves the truth of this. Yet Miss Hepworth says that she wants to discover 'Some absolute essence in sculptural terms giving the quality of human relationships.' The absolute essence of human relationships! Work with such a motive can get no nearer to interpreting a human heart or a human predicament than the Kinsey Report.

An art expert describes one of Miss Hepworth's works – roughly a sphere scooped out into a spiral – as follows:

> The total effect of this form on our feelings is, of course, inexplicable, although we are aware of a sense of enhanced vitality as we contemplate it. The sculptor herself has spoken of its connection with the experience of living between the enfolding arms of St Ives bay, but one feels also that a sense of forces as diverse as those that shape the swing of sea waves and the curves of unfolding ferns has entered into the making of this extremely beautiful and expressive form.

This is as vague, generalized and in the end as woolly

as Miss Hepworth's own statement. It could refer just as well to an aeroplane propeller.

Yet to go further: what is the cause of this evasion of real content, this retreat into an abstract world, or a world so generalized that all identity and therefore all conflict and therefore all vitality disappears? As an artist Miss Hepworth hasn't the conviction to face up to the real consequences of the crisis in which we live. Describing her childhood in Yorkshire, she says:

> It is a country of quite extraordinary natural beauty and grandeur: and the contrast of this natural order with the unnatural disorder of the towns, the slag heaps, the dirt and ugliness, made my respect and love for men and women all the greater. For the dignity and kindliness of colliers, mill-hands, steel workers – all the people who made up that great industrial area gave me a lasting belief in the unity of man with nature – the nature of hills and dales beyond the towns.

She is intelligent and warm-hearted enough to see what is happening. But her solution – the unity of Man with the Nature of hills and dales beyond the towns – evades the whole problem; the problem of how men can make their towns worthy of their 'dignity and kindliness'. This evasion then leads her to this sort of ambivalence.

> When drawing what I see I am usually most conscious of the underlying principle of abstract form in human beings and their relationship one to the other. In making my abstract drawings I am most often aware of those human values which dominate the human structure and meaning of abstract forms.

When she looks at the real she exorcizes a sense of crisis by abstracting it: and when she creates abstractions she

tries to make up for this by imposing upon them a vague, 'safe' human significance. Her attitude is made even more explicit in the following:

> The artist rebels against the world as he finds it because his sensibility reveals to him the vision of a world that could be possible – a world idealistic, but practical-idealistic: inclusive of all vitality and serenity, harmony and dynamic movement – a concept of a freedom of ideas which is all-inclusive except to that which causes death to ideas. In his rebellion he can take either of two courses – he can give way to despair and wildly try to overthrow all those things which seem to stand between the world as it appears to be and the world as it could be – or he can passionately affirm and reaffirm and demonstrate in his plastic medium his faith that this world of ideas does exist. He can demonstrate constructively, believing that the plastic embodiment of a free idea – a universal truth of spiritual power – can do more, say more and be more vividly potent, because it puts no pressure on anything.

She can only conceive of the desire to change the real world as one based on despair, and so inevitably chooses to deal in ideas which put *no pressure on anything* – which form a vacuum.

From all this come the weaknesses of Miss Hepworth's work considered aesthetically. It is because her energy has been spent on inventing a substitute 'ideal' world that she has lacked the passion to investigate *actual* structure. Her straightforward drawings of nudes, when once one has allowed for their tricks of textures, are extraordinarily weak – notice in particular their feet, ankles and hands. It is the ambivalence of her attitude to reality that has led to the emotional split in her work. One moment her

tenderness is excessive, the next it is defensively repressed. On the one hand, her drawings such as those of surgeons and nurses in the operating theatre are extremely senti-mental – everything depends upon the mascara smudges of their eyes: and on the other hand, her sculpture is monu-mentally cold, impersonal, clinical. Finally and most im-portant of all, her desire to contribute something perfect, something above the struggle, has led her to such precision and sheerness of technique for its own sake that many of her carvings look machine made. As a result they deny their own nature as sculpture. Their surfaces are not forced round their corners but slip round with such facility that one's eye takes them for granted and has no compulsion to follow.

JOHN BRATBY

I have been writing art criticism long enough to be proved wrong. At John Bratby's first exhibition, I wrote as follows:

> Bratby paints as though he sensed that he only had one more day to live. He paints a packet of cornflakes on a littered kitchen table as though it were part of a Last Supper: he paints landscapes as if seen from a prison cell: his wife as though she were staring at him through a grille and he was never to see her again. One feels that he paints every picture in order to imprint the subject so vividly on his conscious-ness that he may never lose it. As Bratby develops, this intensity will either lead him to blind incoherence or pro-found discoveries.

The description of the obsessive quality in Bratby's imagi-nation was fair enough. It exists, and at first he was able

79

to turn this quality – or weakness – to account as an artist. It is still claimed that he does this and presumably it was on the strength of this claim that he was chosen to paint the obsessive, outcast 'masterpieces' in the film of *The Horse's Mouth*. But unfortunately it is no longer true and this is where my prophecies went wrong.

Bratby has neither made profound discoveries nor become blindly incoherent. At first, briefly, in 1955 it looked as though he would become incoherent. But after that the factor which I so short-sightedly ignored began to operate. Bratby became successful: The Venice Biennale, Guggenheim prizes, acquisitions by museums throughout the English-speaking world. (He is not acclaimed on the Continent because he is too much of a protestant, hostile or indifferent to any tradition.) The image of himself which the art-public now offered him served as a new kind of release. He no longer had to seize upon a face, a tree or a table, to prove the reality of his relationship with the rest of the world: a process of which his paintings were the by-product. Instead he was given a platform to walk upon and an audience to reassure him of his relationship with them. This audience made it clear that he need only paint pictures as ends in themselves, and that these pictures would automatically justify and confirm his existence. He need no longer search for reality; they would come to him and stare at what he was. And so he began to paint himself painting. His hand with a paintbrush in it began to appear in the bottom of his pictures. In itself, of course, this device or idea was not so important; it was only a visible, literal expression of the deeper change that had occurred. He now steadied himself – thus avoiding in-

coherence – by the simple act of putting pigment on to the canvas, by simply playing his allotted part as 'a painter'. It ceased to be necessary to investigate and scrutinize and so secure his subjects. And consequently he made no discoveries. His drawing weakened. His lines of thick paint became thinner and more linear, and people began to talk delightedly about 'his handwriting' as a painter.

(Analyses like this may sound too harsh, particularly when the crucial point of the argument is the psychological balance of the artist concerned. But if we do not work on the assumption that the truth is salutary, we shall cure no one and nothing.)

In Bratby's recent work the result of what has happened to him is clearer than ever before. Many of his new pictures are of tall figures in rooms, and in several these figures represent the same person seen in different positions or different clothes. The way these rather static figures stand side by side, their blank staring eyes and their thick squirts of paint, separate and unmixed like tesserae, suggest – very superficially – certain Byzantine mosaics. But at the bottom of these pictures are the artist's hands painting; here you can't help feeling the saints have been canonized just because Bratby has painted them.

Yet even this superficial resemblance is only in terms of the stiff pretension of the images: in form and design these pictures are not, of course, in the least Byzantine. Such formal unity as they have is simply gained by the continuous, restless revolving of the artist's paint-marks – the folds of clothes, strands of hair, the grain of wood, the design of the wallpapers, the tread of tyres, the lines on a face, window frames and furniture legs, all indiscriminately

become, as it were, grist to their revolving mill. It is as if he dips a pen into the appearance of these objects to sign his own name. The signature is emphatic and unusual, and it is this which makes his work popular. 'So exciting,' said the well-groomed man with a face like a silver sugar pot, 'and so original and so TAC-TILE.' But the signature is a sprawling one. It lacks all formal beauty. And by its very nature it can only declare that it has been made by Bratby. What it declares about the subject of the painting is incidental and utterly commonplace. As soon as you have allowed for the coarse thick paint and for a few cock-eyed distortions which are the result of the difficulties of fitting the signature into a given space, you can see that his girls are drawn like fashion plates and his scooters like advertisements in a trade paper.

Once Bratby scrutinized his surroundings – greedily – like a man under arrest being led down a street to the police station. Now he signs for things and it is the validity of his chits to which he clings. Yet he himself cannot entirely be blamed for this change, and neither position – whether real or symbolic – is to be envied. The point to remember is that in one way or another this is the transformation which the rewards of our society usually bring about.

Artists who struggle

HENRY MOORE

I believe that Henry Moore himself considers that most 'interpretations' of his work are so much nonsense. He is probably right. Not only because many critics are fools, but because the problem of the meaning of his work haunts him and forces him round in circles so that finally his inability to solve it actually supplies him with his subject matter. On certain occasions Moore has tackled straight subjects – the Madonna and Child, the Dead Warrior, the War Sketch Books. On other occasions he has got lost and confused and so produced works which are objects and not images at all. But most of the time he has to wrestle – even if unconsciously. And so must we, too, but consciously and logically. We can, of course, simply say that Moore has the ability to create forms that somehow please us and then use words like Dignity, Strength, Power – words offered to mysterious gods. But in time these words wear thin, and if Moore's work is to last, its significance must become clearer.

Take his figure for the Unesco building in Paris. A reclining figure is what it is called. Probably feminine. The forms of the body rounded, hollowed out, transported and transformed. If it wasn't for the head on the neck it would be difficult to recognize as a figure at all. Given this clue, however, the forms do become readable. Yet as what? As

you walk round the work, the five massive earth-bound forms change their relationship with one another, change their formation as easily and freely as five birds in the sky. And in the pliable imagination suggested by that, you recognize Moore's mastery. Yet mastery for what purpose? A master makes the form of a work seem inevitable. Then this inevitability challenges the inevitability of nature in the name of something. In the name of what does this sculpture challenge? Why do three boulder-like masses fuse together to challenge two legs? The questions nag. You respond to the work. You say to yourself: the meaning of art cannot always be made explicit in words. But imagining yourself a sculptor, you also sense that no one could go on from where Moore leaves off. And no one has. Why?

The distortions in this work are not emotional in the expressionist sense: they clearly don't reflect the artist's attitude to his subject, if his subject is assumed to be a woman. Nor are they structurally analytical: they reveal nothing about the way a body moves, grows or is controlled. They don't, in other words, take us *beyond* static appearances, propelled forward by either emotion or dynamic knowledge. On the contrary, Moore's distorted forms appear more immutable than any living appearance. They are dead? Not quite. More dead than alive? Yes, but what is more dead than alive? Inorganic matter. And there you have it. Moore's subject here is not a woman: it is the inert material he has in his hands. This work doesn't challenge the reality of the human figure: it challenges the reality of the meaningless mass that it might so easily have been. It is an object striving to become an

image: a prophecy of life not yet manifest. And so it seems to me that Moore's work represents effectively and truthfully the modern artist's struggle to achieve vitality, to discover a theme. It poses the problem, it begs for a solution, but it does not offer one. It is art which has voluntarily put its back against the ultimate wall. Which is also why no one can follow Moore. One can't go further back than he has.

CERI RICHARDS

And having been a little chastised, they shall be greatly rewarded: for God proved them and found them worthy himself. As gold in the furnace hath he tried them, and received them as a burnt offering. And in the time of their visitation they shall shine, and run to and fro like sparks among the stubble.

This passage describes the underlying theme of nearly all Ceri Richards's recent works. Their actual subjects may be pigeons in Trafalgar Square or bee-keepers, music on a piano, nudes or a kind of pagan Pietà inspired by Dylan Thomas's *Do not go Gentle into that Goodnight*; but I think that in the artist's mind all these subjects in some way express the cycle of birth, procreation, death and birth. How banal of course it sounds when written like that – the words so glib compared with the process! But then that is exactly one of the reasons why we need poets – and painters like Ceri Richards; they make images that bridge the process, so that from them we can look down on it, wondering, as at a river.

On the whole critics have been so busy pointing out that

Richards has borrowed phrases from Max Ernst, Picasso, Matisse, that the most important feature of his imagination has been overlooked. Richards is one of the most physically, sensuously *instinctive* painters working here today. (N.B. An instinct is not a whim.) In this respect he might be compared with Matthew Smith, but Smith is entirely concerned with the pleasures of the senses, whereas Richards is concerned with another of the constant but more poignant themes of poetry – the passing of time.

The fact that he never rationalizes this but somehow distils it through his visual imagination from the instinctive reactions of his whole body explains both his faults and achievements. It explains why some of his pictures are incoherent and almost impossible to 'read'. His *Summer* or his *Seasons* (despite a just legible horse and rider) might be taken for abstracts. But they are not. They are physical intimations which have as yet barely surfaced in his imagination. It also explains the physical power and unforced metaphorical richness of his successful works.

Let me give examples to clarify that. Four pen and ink nude drawings have a power which is based on years of careful study and observation, but which is *driven* by his imaginative memory of how a woman's body might revolve from head to foot with his own – and if that angers or stimulates the over-sophisticated because it suggests pornography, they will be disappointed. It simply means that the arm he is drawing flows instinctively and passionately from his own arm as he draws with it; and, although a good number of works created in such a way must fail, the ones that succeed have the breath of life in them. He draws them as one ties a bow – the bow that death undoes.

Artists who struggle

And it is this undoing that is the theme of the two paintings on the Thomas poem. In the better one of the two the body lies, bruised and suddenly useless on the ground, and, above, an owl flies pulling a sheet in its beak. Whether to wind him in it, or to fly across the land with his inscription upon it, we do not know. Probably both. And there is the beginning of Richards's affirmative richness of metaphor.

The fact that Richards has always painted many pictures of the same subject confirms, I think, my point that for him his subject is a 'way in' to an underlying theme. There are six canvases called *The Beekeeper*. The initial experience was seeing an old man with a walrus moustache and his net over his head and shoulders dealing with a swarm. But during the process of painting, the mesh of the net suggested the cells of the comb, and the yellows of the sunlight and the honey and the pollen combined to make a cap or a halo of the towers of Babylon for the old man whose hands remain the only calm, still things in the picture. These are paintings of the process of consummation; the flowers, the summer, the gold, the furnace, all ignite one another whilst the old man in the middle gathers the bees who fly like sparks among the stubble.

What does all this add up to? How important is Ceri Richards? He is the kind of artist who suffers most from our lack of any collective mythology or symbolism. There is no framework in which he can set his instinctive intimations. Therefore he is often incoherent and obscure. But if he had painted nothing else but his canvas of the corpse and the owl, we would have to recognize him as an artist in a hundred. Whether he develops as he should depends upon whether we employ him properly.

Permanent Red

Against the odds of neglect, misunderstanding, and fashion, William Roberts has continued during twenty years of isolation to work and believe in himself undeviatingly. He has remained as defiant as his self-portrait in the Tate. And as a result he has become probably the most under-estimated artist in the country. In fact, as a draughtsman, and as an organizer of the elements of a painting, there is no one working in England today who is superior to him. In the landslide of post-war romanticism he has stood as firm as an undislodged, classical rock, faithful to Poussin, his early cubist apprenticeship, and Léger. How I wish that the truth went no further than that. But in tribute to an artist of remorseless integrity the critic must also be remorseless. In Roberts's paintings no passage is 'fudged'; everything is declared. And so one must add that if only Roberts had been able to believe in something other than his own work, he would have been twice the artist he is. Our art-world today is pertly proud of those whom it 'discovers'. Its losses are naturally unnoticed. Yet if Roberts had been working in a different context, his vision and faith would almost certainly have been able to expand instead of contracting.

As it is his work reveals a hero and a tragedy. There is his heroic and uncompromising method of painting. Like every classicist he is concerned with making statements that make sense without reference to either his own or the spectator's temperament. He strives to create an anonymous art. The local, not the apparent, colour of every

88

object is respected. Each figure reveals the meaning of its actions by a definite gesture. Every square painted inch is unambiguous – there is no flirtation with doubt. His subjects – buses, shop-windows, soldiers, holiday-makers – are taken straight from the everyday material world to which everyone belongs. His masses are simplified to emphasize, not some incidental trait of character, but their essential physical movement: the soldier who carries off a Sabine has to lift ten stone. His forms are organized on the surface of the paper or canvas to establish a separate rounded-off unity that prevents any form trailing its hand to accost the passer-by; the classical image must be self-sufficient and timeless. It is the discipline of this method that has guaranteed the continuity of Roberts's powers of draughtsmanship and composition. (Those who complain that he has not developed make the same complaint about the most developed artist of our time – Léger.)

Roberts, then, paints noble pictures which remind us of the nobility of painting. But that is all. His subjects never gain any credit from his good painting – as they do in Veronese, Poussin, David. One of his watercolours is of shop assistants assembling a dummy in a window. One of its detachable arms lies on the ground. That arm has been felt and painted in exactly the same way as all the living limbs in the other pictures. Why? Roberts is an artist of great sensuous awareness; his colours, his love of physical energy, his women who are too big for their clothes, all demonstrate this. Equally, he is obviously interested in people and their lives. He observes the way a woman tries on a shoe in a shop, or the way a sailor dances, with a mime's accuracy. Why, then, can he only create a com-

pany of dummies, of beautifully made guys and dolls? Because, I believe, he has been forced to contract, to defend his great talents instead of using them to the full. He believes in human reason and the dignity of art, but not in men. And so in every picture his approach is noble and his conclusion mocking. He himself makes what is sensuous in his painting slightly comic, the clear gestures slightly ironic, the nobility of the style slightly absurd in relation to the triviality of the subject. He mocks his gifts by his very use of them. Within the confines of one small picture, classicist, satirist, decorative colourist, social commentator, are all incongruously there for the sake of their defensive alliance. What, one wonders, might each not have done, confidently, generously, on his own? However, there is usually a way through for a rough kind of justice. And without any doubt William Roberts will be remembered and admired for his remarkably lucid exposure (half very conscious on his part and half unconscious) of the values of the society that made no use of him. Not many will achieve as much.

JOSEF HERMAN

Herman is an impressive artist for three reasons. He is a born draughtsman; his later drawings are more compact than his earlier ones, their boxes of space are more firmly constructed, but behind them all is the immediate ability to see the movements of the human body in terms of mass and force of gravity. All his figures propel themselves, self-sufficient, with their feet on the earth; and, simple as that may sound, it is one of the acid tests of draughtsmanship.

Secondly, he is a skilled and imaginative craftsman. He wants his paintings to be like secular altar-pieces: sombre but glowing, rich in colour without being luxurious, definite and yet mysterious. That they are like this is largely the result of the way he actually paints them: first working out the forms very carefully in drawings and then slowly and certainly underpainting on the canvas and gradually enriching with glazes. Thirdly, he has a remarkably strong and undeviating character as an artist. His vision is absolutely consistent. We are forced to see all that he paints according to his own scale of values. It is comparatively easy to formalize a working figure, and by this formalization to emphasize stamina, endurance, silence; but it is very much more difficult to include in the same picture a dog, a sunset, a telegraph pole, and to make these also express the same qualities. Yet Herman always succeeds in achieving this.

Strong draughtsmanship, profound technical skill, a unified imagination – what more does a painter require? Why is Herman not as yet the painter he might be? The charge that his work is depressing is usually made by those who would prefer to forget that their so-called connoisseurship is the result of men working until the sweat stings their eyes. The charge that he is repetitive is usually made by those who require novelty to counteract their own boredom with themselves. Nevertheless both charges have a certain amount of truth in them. There is a repetitive passivity, a certain sense of hopeless endurance in many of Herman's works, and this also affects their actual visual quality.

If you compare objects in a landscape at dusk with the

same objects at dawn even when lit by precisely the same intensity of light, you will notice an immediate difference; at dawn the objects appear to emerge from the darkness, and at dusk they appear to sink back into it; in other words, the way the shadows linger or gather shows instantaneously whether the light is coming or going. In Herman's dark coppery canvases all the forms appear as they might at late dusk, as though they were just about to be lost in what De Quincey called 'the raven's twilight'. In Rembrandt the dark is there for the discovery to flare against: with Herman the light sheathes all sharp edges and creeps on like a thief. And it is this which gives his work, despite all its positive qualities, a certain visual limpness. In some of his larger pictures, especially in the huge panel of *Miners*, if the figures were silhouetted instead of half lost, even their broad forms would seem sodden and dusk-logged.

Marxist analyses of art have often over-simplified to absurdity. But Herman's weakness *is* simple – though that is not to say that it is easy for him to overcome it. The really significant fact is that Herman has spent many years painting miners as if they were peasants, instead of one of the most lively and militant sections of the proletariat. His pictures of true peasants are exactly the same in mood as his pictures of miners. For him, as for Millet, the symbol of the strength of labour is the peasant, but unlike Millet he does not make us believe in the rewards of the after-life, and, accurately enough, cannot find in the peasant's position today any very certain promise of juster rewards in this one. Hence his mood of passive endurance.

Artists who struggle

Why Herman should have to distort the miners amongst whom he actually lived is not so simple. He does not lack either political knowledge or spontaneous emotion. I suspect that the clue is in his early work. As an exile he understandably carries within himself a great weight of sadness and nostalgia. And I feel that even after he rejected this as direct subject material for his work, he projected it on to his new material. His desire to create 'altar-pieces' is, I think, partly connected with this. After he has completed his ink drawing, derived from sketches and direct observation, he changes very little and seems to forget about his subject and to concentrate entirely on producing the rich, awe-inspiring image which he hopes will somehow give a timeless, general meaning – a kind of universal consoling recognition – to the life of his subject. And it is in producing this kind of awe, because it is in fact false – miners need leaders not consolation – that he falls into a subjective formula.

I make these large criticisms because I believe in Herman as an artist. In some of his drawings, such as *The Three Miners' Heads*, in some of his more spontaneous oil sketches, in portraits such as those of *Mike* and *Gwyn*, in his marvellous nudes, he finds and declares the dignity and strength which are in his subject, and imposes no superstitions upon them. And in his less successful works there is still the rare discipline that is the result of an artist knowing that he serves something larger than his own talent. Nor am I suggesting that he paints workers advancing to Socialism as to Sunday School. The confidence to which his own choice of subjects should lead him, is that of Gorki's remark: 'The world will always be bad

enough for the desire in man to make it better never to be extinguished.'

DAVID BOMBERG

'It is a commonplace of art history that many artists fail to receive the recognition which they deserve in their lifetime.' That consoling sentence was written, one year after an artist's death, by a man who could have easily helped to secure the artist the recognition he deserved. The artist is David Bomberg (1890–1957).

Very roughly Bomberg's work can be divided into three phases: up to about 1919 he was influenced by Cubism and Vorticism; after that, in the 'twenties he painted in a painstakingly topographical manner, particularly in Palestine; in 1929 he went to Spain for the first time and from about then onwards began to develop his mature style – largely but not exclusively as a landscape painter.

What is the essential quality of Bomberg's work? From his early Cubist period he learnt to organize a picture surface. From his topographical period he learnt how to observe. In his mature work he combines the two lessons. But this doesn't get us very far, for many other artists served a similar kind of apprenticeship and Bomberg remains unique. (Perhaps the artist closest to him is Soutine, but whereas Soutine appears to be almost the victim of the power of his subjects, Bomberg always appears to be master of this power.) Bomberg himself took many of his conscious theories from Bishop Berkeley. He believed (to quote from Andrew Forge's introduction to the Arts Council exhibition in 1958) that form was 'the

artist's *consciousness* of mass, a subjective thing determined by his own physical experience of gravity, density, texture. . . . He held that the eye knew nothing about form but was merely the feeble servant of a physical sense of form. It was the physical sense of what he called the "spirit in the mass" that was the proper subject of art.'

Such idealism is so foreign to my own way of thinking that I cannot accept its validity or usefulness. But I can see that it was perhaps a partial rationalization of the very special kind of poetic awareness that Bomberg enjoyed and suffered. The image that constantly recurs to me is that of a veil, a curtain, a tent – and each of these in the Old Testament sense of a landscape being possessed by being covered.

> Enlarge the place of thy tent, and let them stretch forth the curtains of thine habitations: spare not, lengthen thy cords and strengthen thy stakes.

Almost I believe that those could have been Bomberg's artistic instructions to his intimate pupils.

The curtain is of course made of paint – often quite thickly applied. It appears like a curtain – despite the fact that the brush marks apply very directly to the forms they describe, hills, buildings, ravines – because these brush marks also have a natural and organic rhythm within themselves which is similar to the rhythm with which material falls into its natural folds. Sometimes the folds are horizontal, when the landscape is a flat plain: sometimes vertical, when the landscape is precipitous: at other times crumpled when the landscape itself is a pocket of land. I do not want to make this image too literal, and

95

I use it only to explain the curious sense of scale which Bomberg's best paintings have – a canvas may represent a mountain range and yet somehow one is made to feel that the artist has laid his hands on these mountains as one can lay one's hands on a blanket – and also to explain their extraordinary unity of light such as one usually only finds in a still life. They appear – in the strict, physical sense of the term – to be the paintings of a giant.

In the latest and greatest of Bomberg's pictures the curtain is absolutely indistinguishable from the real forms themselves. It is no longer a hanging. It is a garment. The grasses, the rock surfaces, the gravel become the dress of the place, and beneath them the body of the place appears to be capable of stirring and moving like a figure. Thus a landscape is given a pose and this pose, as with a man, is an expression of its spirit. Followers of Berkeley would, I suppose, explain that what I am now describing is the universal mind behind matter. But I prefer to believe that it is the result of a man's passionate imaginative identification with the promise or the threat of a place he has discovered. I prefer to believe that it springs from the same kind of vision as the exiled Isaiah's, 'Put on thy beautiful garments, O Jerusalem.'

GEORGE FULLARD

Fullard is the best young (under forty) sculptor whom I know in this country. His works (in bronze or plaster) deal with modern life. By that I do not mean that his work is literal, or that he has a fixed, prophetic concept of what is modern. I mean that he looks at, watches, ponders the

women and children he sculpts far more intensely than he studies other men's sculpture. His work is unusually and profoundly personal and yet at the same time unusually observant. He is one of the very few sculptors who has succeeded in using, naturally and without any premeditation, modern clothes for his own purposes as an artist. High-heeled shoes, short skirts, duffle coats are not in Fullard's work something to add to a nude, or something to substitute for classical drapery, or a formal device to make special play with; they are simply an intrinsic part of the image which he searches to rediscover (having discovered it once in real life) within the confines and climate of his art. And it is the same with facial expression, which is of course a subtler matter. In one of his heads, the sidelong glance of the eyes and the quiveringly attentive mouth are not variable factors but intrinsic ones, the overall form of the whole face holds its own expression just as the form of a full sail holds the wind.

In other words, for Fullard every work grows from a single seed. There is, I suspect, very little constructive or cerebral calculation in his work. Instead there are two intuitive compulsions which, opposing each other, generate a tension similar to that of cerebral thought – there is his intuitive recollection and desire for the image he has seen already in life, and there is his intuitive respect for the narrow limits and thus for the dignity of his sculptural language. Zadkine has, I think, worked with a similar spirit.

Fullard's sculptural language is still one of flattened forms. His works are not reliefs, but equally and quite deliberately they are not all-round three-dimensional

works of sculpture. Each form is extended sideways – so that the effect is the opposite of that of seeing a film too much from one side. This, however, is not just an 'original' trick. Far from it. Its purpose is to make the spectator follow the form with his eyes as a camera follows a race-horse. Yet his subjects are not in themselves so active – a head looking sideways, the torso of an old woman, a mother sitting on a chair with child on her lap. The movement one has to follow with one's eyes is not a physical one, but rather a movement, a development, in time. One is led up to the moment of recognition, and then away from it, changed – just as it can happen that one looks long at a face until suddenly one recognizes that it is beautiful or generous. But because of course Fullard is a sculptor and not a writer, he wants to recognize more than romantic or moral qualities. We follow with our eyes the development of the physical fact of a clenched hand, a crossed leg, a rising breast, and so on for all the forms in the work, until at the moment of recognition we realize that all this and more lies behind and makes up the reality of one woman or one child during one second of their lives. And in this human and tender sense I would say that Fullard is one of the few genuine existentialist artists of today. He opens up for us the approach to and from the moment of awareness.

FRANK AUERBACH

Auerbach's paintings have an extraordinary physical presence. One says naked instead of nude. She is there on her bed. You, by looking and not disturbing her,

cease to be a stranger. The building sites are damp. The mud clings. The tarpaulins are heavy with moisture. The light in the sky is far less comforting than a cup of tea. Do I make the paintings sound literal? Of course I do. It is the curse of words in this context. They are not literal. They are physically real partly because Auerbach has learnt to search by drawing, partly because he understands the intimidating limitations of painting. Let me explain what I mean by that, for it concerns the heart of the problem with which every true painter now has to struggle, and with which we've seen Auerbach struggling for several years.

His earlier works were mud-coloured, inches thick. They looked as if they had been painted in the dark with a candle and a stick. When I first saw them, I recognized the strength of the drawings that accompanied them, but I was unconvinced by the paintings themselves. I now see that they were an essential step in Auerbach's development. Every painter now has to settle for himself the genesis point of his own art. Some choose geometry, for instance. Auerbach chose the density of his pigment. He began with the nearest that a painter can get to substance. Whatever the artist chooses for his genesis will seem inadequate. It will always be like trying to build a house with matchsticks. But it is this inadequacy that he then pushes against. Maybe for years. Always aware of the richness of life and the poorness of art. And then suddenly the inadequacy becomes an advantage. He has turned it to his purpose. The inert deadness of the mud in Auerbach's earlier paintings becomes eloquent now about the weather and the depth dug in the building sites, just as in the nudes it becomes eloquent about

the substance of flesh. If an artist inherits a tradition, his development is made much easier. Here and now no artist inherits a tradition. Consequently he faces two dangers with only his own obstinacy to help him. He can be misled into trying to imitate life. Imitation amounts to no more than a salesman's gimmick: it merely stimulates one's appetite for the real thing. Or else he can be misled into subjectivity. As far as I am concerned the matches are logs, he says to himself, and so happily plays with them and tells himself stories. What he must do, if he is to break through, is to create from discontent. A portentous term. But what it means is that he must accept the limitations of his art. Only from these can he create. His struggle can then be seen as the equivalent of life. And his shock of recognition when he at last achieves something will communicate itself to us – as vividly as a shock received from life.

FRISO TEN HOLT

Friso Ten Holt is about thirty-eight. He has been a painter all his life. He is also an etcher and engraver. His prints are recognized in Holland as being imaginatively better worked than those of any other Dutch artist. Further, he has designed and made some large stained-glass windows. I believe that these windows are more successfully modern than any others I have seen. 'Modern'? The greatness of Ten Holt as an artist could be said to lie in the fact that by considering his work one arrives at an answer to the question, at a valid definition of the word 'modern'.

Eight years ago his work was very highly formalized so that some of it appeared even abstract, mainly influenced

by late Cubist Braques and Picassos. He had previously been taught to draw from childhood onwards by his painter father. His drawing masters then were Rembrandt for landscapes and Cézanne for figures. In his highly formalized works of eight years ago Ten Holt was learning to organize and build across the surface of a large canvas. It was like the apprenticeship of a fitter. His eye was already trained, but he had to learn how to put a vehicle together so that it could go as fast as the Cubists and Mondrian had made possible.

His next step was to paint a canvas (approximately 16 ft × 10 ft) of Jacob wrestling with the Angel. In this all the previous 'structural' lessons he had learnt were used, in relation to a subject that was, as it were, already travelling in its own right because of its own emotional power. (In the same way Picasso was able to use Cubism when he came to paint Guernica.) Ten Holt, however, was not yet capable of being original, and for his vocabulary of forms he went to that great sculptor, Lipchitz. When I hear people talk about there being no epic art today and no artists who can interpret great themes, I think of this large canvas. It is an epic picture, in the tradition of Delacroix's *Liberty Leading the People* – though the museums would never see the connection because they are obsessed with stylistic cataloguing. And it is successful. Jacob wrestles with the Angel like Don Quixote with the sails of the windmill; yet at the same time it looks as still and calm as a catherine-wheel when it is revolving. One would think it the work of an older man: it suggests the austerity of a mature artist who will not step outside his art. He will affect you if he can by his performance. But he

will not smile at you or insinuate round the edges of that performance. As I have said, however, it is not yet an original work. But from its foreshortened flying angel, originality came. (Originality! It is claimed so often, and is so rare, that the very word has become wry.) From the angel in the air flying towards the ground came the idea of a figure entering one element and leaving another. And from that came a series of paintings on the theme of swimmers. Looking at these you realize how unstartling originality can appear. For certainly these swimmers are original. I know of no sensible references to apply to them. In spirit – something of Veronese. In colour – certain Van Goghs. In touch – something of Cézanne. Yet they could not have been painted before the 'fifties. An impossible sounding pedigree! Bastards. Originals.

I have given this compressed history of Ten Holt's development in order to show the nature of his apprenticeship. This apprenticeship has only just ended and he is nearly forty. It takes a long time to become a painter such as he has become. Naturally he has painted many pictures which I haven't mentioned. But he works slowly and his output is small, because the path he has chosen is one of the most difficult an artist can choose today. (De Stael chose a similar path, but got less far along it.) It is the path which leads from a complete understanding of the laboratory experiments of twentieth-century art forwards towards their application to life. It avoids romanticism. Its aim is objectivity, but not naturalism. Its spirit is rational. Its faith is in art itself and yet it is entirely opposed to art for art's sake. There is another kind of artist whose genius is a by-product of his passion. In our time Guttuso is such an

artist. But for Ten Holt everything must be produced with direct intention.

His attitude is in fact admirably demonstrated by this very painting of *The Swimmers*. It represents two nude figures, a man and a woman, in the sea. Like all images that are the result of profound searching, it has many meanings. (The great illusion of current non-art lies in the belief that numerous meanings can be expressed without searching.) They swim in the sea. They turn in their dreams. They twist in sex, all lights and weights, the embodiment of caresses and invisible responses. (George Barker: 'O whirlwinds catching up the sea And folding islands in its shawls Give him to me, give him to me, And I will wrap him in my shallows.') They fly like Icarus. They play like children – their speed their *joie de vivre*.

But the painting as a whole also has another significance. The water, the air and the figures are indivisible. It is impossible to define either the form of the limbs or the colour of the water or the strength of the light *separately*. Without the figures in it, this sea would be another ocean. Without water to bear them, these lovers would be a different pair. Flesh, water, air, each element possesses the other, because all are subordinate to the element of painting.

When I said that the idea behind the series of pictures was that of a figure leaving one element and entering another, I did not only mean it literally in relation to two swimmers entering the sea; these pictures also demonstrate how two figures enter the element of painting itself. Ten Holt believes that painting is an independent element with its own laws and demands. If an image enters this element and does not satisfy its demands he believes that it will

have neither the necessary power nor conviction with which to comment on the different demands which life makes. Art, in other words, is neither a replica nor an extension of life. It is independent. But it is independent only because it is a parallel phenomenon, just as water is a parallel element to air.

One could sum all this up – but without the foregoing explanation it wouldn't mean much – by saying that Ten Holt is a classical artist. (The Romantic believes that the connection between art and life is not the result of their parallel laws, but of his own personality free to inhabit both worlds as it chooses.) It has been easy to be a classical artist. Today it is immensely difficult. And immensely necessary. Personalities are destroying art. The great modern discoveries lie unused. The responsibilities of the day pull one way; cowardice and manias pull the other way. Incommunicability is thought to be the theme of our time. How difficult to remain confident and dutiful as it becomes an artist to be dutiful, in the midst of such a din! And how difficult to accept being abused as old-fashioned and academic! Yet this is the fate of the original artist today. The function of the original artist is to renew the tradition to which he belongs. In the nineteenth century most people had a nostalgic view of their tradition and so considered originality outrageous. Today our cultured have gone beyond nostalgia; in their despair they hate all but the violently primitive, and so originality becomes an act of faith which offends them because it questions their illusion of freedom from all traditions.

One day, with the advent of new visual media and a society not based on alienation, the modern tradition will

be continued. Then artists like Ten Holt (perhaps there are half a dozen in Europe) will be seen to have been heroes. Not because they were politically conscious heralds of that new society – that is another way of living; but because they obstinately believed in *the continuity of art* at a time when most, doubting the continuity of their own way of life, wanted to destroy all continuity. And to believe in continuity is to be modern, is to be – for us who can respect nothing else – revolutionary.

The development of
twentieth-century art

Intelligent thinking about the nature of twentieth-century art is bound to lead to the question of Formalism. That is to say, the question of what is justified and unjustified distortion. Or, to put it another way, the question of how the artist can achieve a balance between his allegiance to nature and his allegiance to the independent image he is creating. Volume upon didactic volume has been written on this subject. But at the Tate there are four bronze reliefs by Matisse which reveal more about the problem than words have ever done. Indeed, these four works could form the basis of a whole system of art teaching.

The reliefs represent the back view of a standing nude woman, slightly over life-size. They form a progressive series and were modelled between 1910 and 1930, the first being the earliest and the fourth the latest. The woman leans forward against a wall, her head resting on her raised left arm.

The first work, obviously done from life or from direct drawings, is comparatively representational. Its simplifications are less radical than those of Renoir's *Woman Washing*, which stands nearby. But whereas in the Renoir the simplifications emphasize peace, comfort, security – the aftermath of love – Matisse's relief stresses vigour, energy and the tactile excitement aroused by sex. The

planes round the shoulder blades and spine have been cut sharply so that the light throws their arched strength into relief. In other passages the bronze is given the density of flesh, but provocatively so. The woman's breast is pressed sideways against the wall, the taut muscles, of the stomach we cannot see push her buttocks into our hands. In other words, in front of this work our attention moves from part to part, propelled by our own physical awareness of the woman's presence. And this was clearly Matisse's intention. It is not a literal work. It does not simply represent a naked woman. It represents a woman clothed with our own sensuous and sexual reactions. Here a hip is not just a hip but a hip transformed and re-surfaced by our sensations of touching it. The front of the body is only turned away from us; we still believe in it, have expectations of it. Thus, the wall, the bronze plate she leans against, is a device, an interference. She belongs to us rather than to it.

In the second relief the parts of the body become dislocated. They no longer conform to the logic either of the woman's own energy or of our sexual reaction to her as a woman. Here Matisse begins to improvise from his general experience as an artist rather than a man. It is as if he now wishes to destroy the first immediate image – as one might smash a vase – in order to let the light into it. By this light he may later be able to invent, to create. The back-bone line is broken. The shoulder of the raised arm is enlarged. The breast has become a short jetty jutting out from the straight coast line of the upper arm and torso. The wall the woman is leaning against has become a sea out of which a feminine landscape now rises. Indeed, as landscapes go, it is very feminine; but as bodies go, it is a quarried, ter-

raced, ravined landscape. We can wander through it more impersonally than we could touch the first. We can forget our own sex. We can be surprised both at the precipitousness of rock-faces and at the variety of associations conjured up for us. But we cannot, as from the first work, draw any conclusions. We are in a limbo between the senses and intelligence, woman and landscape, memories of our own sex and the faint possibility of being confronted with something new.

In the third relief Matisse found something new. Glance now at the Maillol torso across the room and it looks as if it were made in a museum, as if Maillol only looked at a body to discover the Greek in it. The Matisse body has become straight. The breast and shoulder have merged to become just the fulcrum of the raised arm. The buttocks have disappeared to become the rounded heads of the shafts of the two legs. There are now only four parts to the body: these two shafts and the two levers of the arms. And the new element, the invention? The woman has grown her hair and it now falls in a single straight tail from the head, between the levers, between the shafts, to be lost in the background, the wall, at a point level with where her buttocks would crease if you could still see them. The background itself is now neither interfering barrier nor mysterious sea: it is a flat plate of bronze out of which five new clumsy forms are emerging.

In the last relief the clumsiness has gone. We confront a clear, new object, never before seen. You mean you are thrilled by its novelty? No. The point of its newness is that this makes it complete in itself. It owes nothing, is solvent as a goddess. The woman no longer belongs to us. She

belongs to the bronze plate. She now consists of just three forms, three parts, each of them simpler than any of the fifty parts in the first relief. On each side of the figure, arms, shoulders, hips, buttocks, thighs, knees, calves have all become one form, one pole. These two poles, slightly inclined towards each other, are now the figure. Between them falls another – the tail of hair. This cleaves between the other two, phallus-like. So the body has been reduced to a sexual sign? Again, no. Far from it. All Matisse's experience of the fifty parts of the first figure is still present in this work, in the subtle undulations by which the three poles, the three branches differ.

The fourth relief is still recognizably a woman. It differs from the first as an aeroplane differs from a bird. Both aeroplane and bird are clearly designed for the same activity – flying. The aeroplane is different in that it is entirely man-designed. In the first relief Matisse's reactions to a woman's back are, as it were, grafted on to the natural forms of her body. She is, as I said, clothed with our (or the artist's) sexual awareness of her. In the last relief Matisse's reactions are the seed from which the whole work has grown. That is why I said it was entirely man-designed. In the first work the surfaces of the forms we see are a point of departure: by stimulating us they begin an experience. In the last work the surfaces of the forms we see are a point of arrival, a conclusion, finally reached at the very end of the experience that the work embodies. We can go no farther. We have no expectations because the figure does not belong to us. It belongs to the bronze of which it is made and the seed from which it has grown. It represents life because it has had a life of its own.

Permanent Red

Those artists who now think they can begin at stage four and leave out the three preceding stages must be either charlatans or fools.

Twentieth-century masters

JUAN GRIS

By temperament Gris appears to have been obstinate, cold, mean, but courageous about his health – he died at forty; his great virtues as an artist were his intelligence and clarity, the latter quality being the result, as with Stendhal, of an extreme, disciplined frankness. He was as near to a scientist as any modern painter has been, and thus, because Picasso's and Braque's discovery of Cubism was the discovery of a formula, Gris was the purest and most apt of all the Cubists.

It may seem shocking in our period of hysterical individualism to say that Cubism supplied a formula. Yet this was its unique advantage over all other twentieth-century movements, and is why many second-rate artists who came under its influence were temporarily made first-rate. At its best it was not, of course, a formula for making pictures, although it finally became that; it was a formula for interpreting and understanding reality.

Theoretically, the reality of an object for a Cubist consisted of the sum total of all its possible appearances. Yet in practice this total could never be arrived at, because the number of possible visual appearances (or aspects) was infinite. Consequently, the most the Cubist could do was somehow to suggest the range of, the infinity of possibilities open to, his vision. The real subject of a Cubist painting is not a bottle or a violin; the real subject is always the same,

and is the functioning of sight itself. The bottle or the violin is only the point of focus, the stake to which the artist's circling vision is tied. (The Cubists' trick of imitating the surfaces of the objects they were painting – by wood graining, marble patterning, etc. – served to fix this necessary focus in the quickest possible way.) To look at a Cubist painting is like looking at a star. The star exists objectively, as does the subject of the painting. But its shape is the result of our looking at it.

The artist, in other words, became his own subject, not in any subjective or egocentric manner, but as a result of his considering himself and the functioning of his own senses as an integral part of the Nature he was studying. This was the formula for Cubism and when Cézanne insisted on being faithful to Nature via his *petite sensation* he predicted it. Again, however, I want to emphasize that by formula I mean a new, revolutionary truth, which, once posed, can be generally learned, taught and applied. Why revolutionary? Because, simultaneously with the scientific discoveries of that period (Rutherford, Planck, Einstein) which were just beginning to give man, for the first time in history, the possibility of an adequate control of his environment, the Cubist formula presupposed, also for the first time in history, man living unalienated from Nature. And it is perhaps this which explains why those few Cubist pictures which were created during the years immediately preceding the first world war are the calmest works painted since the French Revolution.

Following the war and its consequences, the prophetic confidence of the Cubists was broken. They had enlarged the vocabulary of painting, but the revolutionary meaning

of what they had added was largely forgotten. Only Léger remained consistently faithful to the original spirit of Cubism: Picasso was so spasmodically: whilst Braque and Gris withdrew into decorative idioms – Gris in an architectural spirit, Braque with the spirit of an epicure poet.

It still seems logical to believe, however, that when eventually a modern tradition of art and teaching is established – and this tradition will inevitably be materialist in philosophy and uncommercial in context – it is to Cubism that its exponents will return as a starting point.

LIPCHITZ

Critics should always look their hobby-horses in the mouth. Yet despite this warning, the more I think about the art of the last and the next forty years (which is the minimum time-span with which any critic should concern himself) the more I am convinced that the question of Cubism is a – and probably the – fundamental one. Cubist mannerisms are of course widespread, but it is not to these that I refer; stylistic mannerisms are the small-talk of art. It is the Cubist attitude to nature, to the content of art, which has opened up so many real and truly modern possibilities.

The static single viewpoint in painting and sculpture can no longer satisfy the expectations deriving from our new knowledge of history, physical structure, psychology. We now think in terms of processes rather than substances. Many twentieth-century artists have expressed this shift and progress in our knowledge by using unusual, eccentric viewpoints whose significance depends on vibrant comparisons, made outside the picture, with other less eccentric

viewpoints. This is the principle behind expressionist distortions and surrealist juxtapositions. Their success depends on – as it were – setting the viewer spinning. Their argument is: a form is not in fact what it appears to be, and therefore if we wilfully deform it we can usefully make people doubt the apparent truth; so let us cast off and trust to the unknown currents. The reduction to absurdity of this attitude is the worship of the accident, as in Action Painting.

The Cubist attitude is totally opposed to this. The Cubists established the principle of using multiple viewpoints *within* the picture and therefore of controlling the spin and the vibrations of meaning. They were concerned with establishing new knowledge rather than with destroying the old, and so they were concerned with statements, not doubts. They wanted their art to be as self-sufficient as the truth. They aimed to disclose processes, not to ride hell bent down them into ferment. They were not of course scientists. They were artists, and so they connected one phenomenon with another by an imaginative rather than physical logic. Human consciousness was their arena as well as their tool. But they were almost unique in modern art in that they believed that this consciousness could be considered rationally, not, as all romantics believe, just suffered.

Readers might now reasonably assume that I am talking about the classic Cubist works of 1908 to 1913, and that when I say 'multiple viewpoints' I mean it literally and optically. The true consequences of Cubism, however, are far wider, and nobody illustrates this better than the sculptor Jacques Lipchitz, along with Zadkine among the few possibly great sculptors of our time.

Lipchitz would be the first to admit that he was formed by Cubism. Indeed, from 1913 for about ten years he produced sculpture which looked very like early Cubist paintings: the same scrolly shapes, sharp edges, lack of depth, and even the same subjects. These were the works of his apprenticeship. Mostly they fail as sculpture. The forms have been taken too directly from painting. They look like canvases seen through stereoscopic spectacles. But from the middle 'twenties Cubism ceased to be a matter of style for him, and became a question of imaginative vision. Some of his new works were open wire-like sculptures; others were massive figures, a little like the sculptural equivalent of Léger's, with surfaces sometimes polished and sometimes very broken-up. All, however, were metaphors in movement.

I fear that that is an obscure phrase but perhaps I can clarify it by an example. There is a large work of a pair of lovers on the ground. The forms are very severely simplified. There are no hands, no feet, no faces. One mass presses down on another. Their four legs have become two simple forms – a little like the front wings of a car. The man's arms connect two shoulders – his own with hers. Their heads, both bent backwards from the chin, form a shape like an open beak, his the top bill and hers the bottom. In profile the whole work looks somewhat like a tortoise – the shell their two bodies – raising itself up on its legs. But its spirit is not in the least zoomorphic. It is cast in bronze and its forms are metallic. Just as much as a tortoise, it also suggests a fulcrum, levers and counter-weights. Its distortions and simplifications have not been governed by the material as in Moore, nor by emotional urges and fears

as in Marini; they have been very carefully derived from the objective structural stresses and movements of the subject. Hence the energy of the work. It springs from its own base. Rodin, whom Lipchitz much admires, was also concerned with movement, but for Rodin the movement of a figure was something that happened to it. For Lipchitz, concerned with processes rather than substances, and looking in imagination from multiple viewpoints, movement is the very mode of being for his figures.

Poetically this means that he conjures up allusions to all forms of movement: to the wind, to animals, to fire, to plants opening, to gestation. His refugees fall like stones from a collapsing building; Prometheus strangles the vulture (an intended symbol for Fascism) as wind strangles a flame. His happy figures are like new boats on the stocks. Orpheus rediscovers his love and they are like two clouds in the sky.

Ideologically it means that he is in a position to make the truthful symbols of our time. Speed is rightly – but not just in the sense of travelling fast – our special concern. We aim to set processes in motion. Only gods are static. And historically it means that Lipchitz has learnt, when he is at his best, the lessons of Cubism: has learnt to control the spin and produce a modern rational art.

ZADKINE

In May 1940 the centre of Rotterdam – including, among other buildings, 25,000 homes – was bombed to rubble. It was the second European city to be a victim of the German policy of extermination bombing. Warsaw was the first.

Twentieth-century masters

On the waterfront of the new city there now stands Zadkine's monument to the ordeal of the old city. It is a reminder of which the citizens of Rotterdam are almost unanimously proud. It is a memorial which can shame those Germans capable of admitting shame. It is an inspiration in the struggle for progress and peace. And quite apart from this, it is – in my opinion at least – the best modern war monument in Europe.

You can only see it properly by walking round it on foot. It stands by itself, well away from any road or large building, overlooking the harbour. Although near the centre, this is one of the few quiet, still places in the modern city. You walk round the plain granite block on which the figure, cast in dark bronze, simultaneously stands, dies and advances. The scale is big. Two or three large gulls can perch on the hand that appears to be flattened against the surface of the sky. Between the outstretched arms the clouds move. A ship's siren sounds on the other side of the water, and you think of the largest anchor, but buckled, and trailing not over the sea bed but over those moving clouds. At night it is different. It becomes a silhouette, less symbolic and more human. Shadows, which are half the visual language of sculpture, are obliterated. Only the gesture therefore remains. A man stands, arms raised to hold off an invisible load between him and the stars. Then in the early morning you see again the lime of the gulls and the dead fixed texture of the massively cast bronze in contrast with the bright, crinkling surface of the water. Thus the sculpture changes with the time of day. It is not a passive figure with a corrugated cloak waiting to be benighted, lit up, scorched and snowed upon until it becomes

no more than the unmeltable core of a snowman. Its function and not just its appearance depends upon the hours. It engages time. And the reason for this is that its whole conception as a work of art is based on an awareness of development and change.

But first let me admit that there is one very weak passage in this work: the tree stump by the side of the figure. An upright form is necessary there to support the figure, but both the shape and the associations of a tree stump are quite unsuitable: like a potato by the side of a crystal. However, it is almost possible to ignore this. It is not part of the figure and it is not part of the work's true image.

What is the meaning of this image? Or, rather, what are the meanings? – for it is the fact that this work has simultaneous meanings that allows it to express development and change so well. The figure represents the city. And the first dominant theme is that of the city being ravaged, razed. The hands and the head cry out against the sky from which the man-aimed bombs fall. I say man-aimed because this makes the anguish sharper and fiercer than that of an Old Testament prophet crying out against the wrath of his god, and this extra anguish partly explains, I think, the violence of the distortions in modern tragic works like this. The torso of the man is ripped open and his heart destroyed. The wound is not portrayed in terms of flesh. The man represents a city, and the sculpture is of bronze and so the wound, which in fact is a hole right through the body, is seen in terms of the twisted metal of the burnt-out shell of a building. The legs give at the knees. The whole figure is about to fall.

The second theme is very different. This is also a figure

of aspiration and advance. The heart is ripped out, but the arms and hands are not only held high in anguish and a vain attempt to hold off, they also raise and lift. The legs not only give at the knees, they also bend because they are steady. And from every direction as you walk round this figure, the step appears to be forwards. The figure has no back – and so cannot retreat. It advances in every direction (and do not think I am now talking metaphorically; I am being quite literal.) On the site of the old city a new one was to be built. One week after the German attack, plans were made to rebuild Rotterdam after the Germans were eventually driven out. And so the curses also become a rallying cry.

How does the work achieve this duality? Not by philosophic dualism, not by separating the spiritual from the physical – as in certain crucifixions where the body of Christ is tortured and the expression of his face peaceful and triumphant. This is a work which is uncompromisingly physical and the basis of its double meaning is a material one. First, the statue has an existence and logic of its own. It is not imitative. It is a piece of bronze demonstrating something and it does not disguise the fact that it is a piece of bronze: its forms are metallic in both shape and tension. This allows it to express the content of one moment – the moment of dying or the moment of resurrection – whilst not being exclusively committed to that moment; it also clearly remains a piece of bronze on the waterfront at Rotterdam in 1960. Thus its formalizations become the equivalent of a historical perspective: they do more than generalize, they allow for change. Yet by itself this is a dangerous principle to work upon because it can lead to

that kind of abstraction which 'contains' any meaning because it actually has none. Formalizations governed by the material of the work in question must always be modified and checked by observation of the reality of the subject. And this is the second way in which the basis of the double meaning of this work is a material one. It is not by magic that Zadkine has modelled a figure which simultaneously advances and collapses; it is by learning from the methods of Cubism. He now knows what is constant in all the ways in which a body can move and retain its balance. He can sense the points of physical coincidence between a man falling and a man going forwards. (Who has not mistaken laughter for weeping, a gesture of affection for one of attack?)

And so having established these points and the precise relationship between them – round the wrists, at the pit of the neck, under the shoulders, along the thighs, near the knees – he constructs the form of each limb to suggest, given those fixed points, all its possibilities of movement. The figure becomes like a dance which does not need time to unfold. The dancer's movements have been made simultaneous, but within itself each movement obeys its natural law.

Naturally the way Zadkine actually worked was not as cerebral as I have made it seem; nor is the impact of the sculpture half as involved. It is a popular work, accepted by the citizens of Rotterdam, because its dialectic is a very human one. Unlike most memorials, it is neither gruesome nor patronizing. It does not try to turn defeat into victory, nor does it hide the truth by invoking Honour. It shows that different people can use the words defeat and victory

to describe the same thing, whilst the reality which is actually suffered is something continuously developing and changing out of that apparent contradiction. And it shows this in terms of pain and effort. It stands on the edge of the land. And it is as if this figure has crossed the world and come through history to stand on the most advanced point to meet those who will soon arrive.

FERNAND LÉGER

Our productive, scientific abilities have outstripped our ethical and social conscience. That is a platitude and no more than a half truth, but it is nevertheless a way of summing up at least an aspect of the crisis of our time. Nearly all contemporary artists who have faced up to this crisis at all, have concentrated on the ensuing conflict of conscience. Léger was unique because he seized upon our technical achievements and by concentrating upon their real nature was led on to discover the spirit, the ethics, the attitude of mind, necessary to control and exploit them to our full advantage. It is because of this – because Léger put the facts of our environment first and through them arrived at his attitude to life – that one can claim that he was so boldly a materialist.

As an artist Léger is often accused of being crude, vulgar, impersonal. He is none of these things. It is his buoyant confidence that makes him seem crude to the diffident. It is his admiration of industrial techniques and therefore of the industrial worker that makes him seem vulgar to the privileged; and his belief in human solidarity that makes him seem impersonal to the isolated. His works themselves

refute the charge. Look at them. I always feel absurdly pretentious when trying to write about Léger. His works so clearly affirm themselves. In front of a painting by Picasso or Bonnard, one senses such an urgency of conflict that it seems quite appropriate to discuss and debate and plead for all the issues involved. But in front of a Léger one thinks: There it is. Take it or leave it. Or rather, take it when you want it, and leave it when you don't. Scribble moustaches on his girls if you like. Buy a postcard of it and send it home along with a vulgar one. Lean against it, and prompted by the bicycle in it, discuss where you're going next Sunday. Let the dumb-bells in another remind you that you've stopped doing your early morning exercises. Or stand entranced and reflect afterwards that he has probably learned more from Michelangelo than from any other artist. It doesn't matter. Look at his bicycles, and his girls in their sports clothes, and his holiday straw hats, and his cows with their comic camouflage dapples, and his steeplejacks and acrobats each knowing what the other takes, and his trees like the sprigs you put into a jam jar, and his machinery as gay as the youth who plans to paint his motor-bike, and his nudes as familiar as wives – what other modern painter doesn't paint a nude as though she were either a piece of studio furniture or a surreptitious mistress? – and his compasses and keys painted as if they were emblems on flags to celebrate their usefulness – does his work seem mechanical and cold?

Léger's greatest works are those which he painted since the war and those in which, dealing with the human figure, he expressed directly the profound humanism of his materialist philosophy. Among these are the studies for his

famous large painting of builders working together on scaffolding, and the monumental heads with their striped flags of bright colours superimposed over their contours.

These heads with their strips of bright orange, red and blue, represent the culmination of Léger's art. Léger began with the machine. His cubist pictures were untheoretical. In them he simply used the cube and the cylinder to re-create the energy of machine blocks and pistons. Then he discovered the machine-made object. Unlike most artists, but like the average man of our century, he was not interested in its associations but in how it was made. From this period in his painting he learned how to manage solids – how to manufacture them, how to preserve a surface with paint, how to dazzle with contrasts, how to assemble mass-produced signs with colour. Later, interested by how colour changed the appearance of shapes and vice versa, he began designing abstract murals. Yet, unlike so many others, he always realized that abstract painting meant nothing if separated from architecture. 'It is our duty,' he said, 'to spread light and colour' – and he meant into the mean, grimed city apartments. From this phase he learned to see beyond the single static object: he learned to connect. And with this formal development came a human one. He saw that the machine had made labour collective, that its discipline had created a new class, that it could offer free-dom. He suddenly saw machines as tools in the hands of men, no longer as mere objects in themselves. From that moment everything he painted ceased to be a celebration of the mechanical industrial world as it is, and became a celebration of the richer human world to which industriali-zation would eventually lead. He painted Adam and Eve

and made them a French worker and his girl granted
Leisure. He painted bicycles as a symbol of the machine
available to the working class which could convey them to
where they wished. And he painted his monumental heads
with their waving flags of colour.

Léger was not one to parade his sensibility as though it
were his only virtue. The bright dynamic colours reflect
what he learned from the machine. The unblinking con-
fidence of the heads, expressed in their faces themselves
and in the steady unchanging contours which define them,
reflect what he learned from those who work machines.
The two then combine. These paintings incorporate all the
formal discoveries of modern art and yet are classic, suggest
order and yet are full of gaiety. The strips of colour run
across many different forms yet are so finely modified and
placed that they give to each a solidity and definition
which is nothing short of miraculous. I have called these
works flags. They are emblems for something permanent
and are as full of movement as pennants in the wind.

In fact Léger was the only modern European artist to
have created an heroic style. Many factors prove this; that
his work has a dignity and a sense of scale which in no way
relies upon his literal subject; that on one hand it is as
formal and architectural as a Corbusier building, and on
the other is as simple in meaning as a ballad; that the
nudity of his figures is less private than any painted since
Michelangelo. He makes his figures nude to emphasize
what they have in common. He calls one picture *Les Trois
Soeurs*. The heroic artist cannot by definition be interested
in idiosyncrasies.

Léger rejected every implication of 'Glamour'. 'Gla-

mour', as it has now come to be understood, stands for everything that separates one person from another, whether it is their 'special' understanding of art or the colour of their lipstick; Léger was only concerned with what we have in common. The current vision of the genius is almost synonymous with that of the mysterious, misunderstood outcast; Léger's vision of the genius was of a man with an imagination so in tune with his time and therefore so easily understandable, that he could become almost anonymous – his works as easy and yet sharp to the eye as popular proverbs to the ear.

He stands beside Picasso. Picasso is the painter of today; his greatness rests on the vitality with which he expresses our present conflicts. Léger is the painter of the future. And by that I do not simply mean that his future as an artist is assured, but that he assures his audience, if they have the courage to accept it, of their future. Yet at the same time Léger was not Utopian. He recognized human vulnerability and allowed for it by the tenderness of gesture and mood of his figures. In a Utopia there might be gaiety and co-operation and happiness but there would be no need for tenderness, for tenderness is the result of understanding human weakness. His *Constructeurs* do not only build together: they also protect one another – as, in practice, men working on high scaffolding must. His portrait of Eluard shows all the doubting that a lyrical poet must undergo. In one of his last canvases, called *Maternité*, the typical bands of bright colour set the drawing flying, as gay as a tricolour, but the daughter's hand touches her mother's cheek with the necessary reassurance that children can give. Such tenderness is not innocent.

Permanent Red

Because Picasso holds the position he does, every misinterpretation of his work can only increase contemporary misunderstanding of art in general. That is the justification for adding a few more hundred to the millions of words through whose mesh he himself always escapes.

Above all Picasso suffers from being taken too seriously. He recognizes this himself and it is one of the ironical themes of some of his drawings. The indignant take him too seriously because they attach too much importance to the mad prices his works fetch and so assume that he – instead of his hangers-on – is a racketeer. The ostentatiously tolerant take him too seriously because they forgive him his excesses on the ground that, when he wants to be, he is a great draughtsman. In fact this is untrue. His best drawings if compared to those of Géricault, Daumier or Goya appear brilliant but not profound. Picasso's future reputation as a great artist would not, as is so often said, be guaranteed by his realistic works alone. The enthusiastic take him too seriously because they believe that every mark he has made, the date on which he made it and the address he happened to be living at, are of sacred significance. The critical minority in the Communist Party take him too seriously because they consider him capable of being a great socialist artist and assume that his political allegiance is the result of dialectical thinking rather than of a revolutionary instinct.

In front of Picasso's work one pays tribute above all to his personal spirit. The old argument about his political

opinions on one hand and his art on the other is quite false. As Picasso himself admits, he has, as an artist, discovered nothing. What makes him great are not his individual works, but his existence, his personality. That may sound obscure and perverse, but less so, I think, if one inquires further into the nature of his personality.

Picasso is essentially an improviser. And if the word improvisation conjures up, amongst other things, associations of the clown and the mimic – they also apply. Living through a period of colossal confusion in which so many values both human and cultural have disintegrated, Picasso has seized upon the bits, the fragments, the smithereens, and with magnificent defiance and vitality made something of them to amuse us, shock us, but primarily to demonstrate to us by the example of his spirit that within the confusion, out of the debris, new ideas, new values, new ways of looking at the world can and will develop. His achievement is not that he himself has developed these things, but that he has always been irrepressible, has never been at a loss. The romanticism of Toulouse-Lautrec, the classicism of Ingres, the crude energy of Negro sculpture, the heart-searchings of Cézanne towards the truth about structure, the exposures of Freud – all these he has recognized, welcomed, pushed to bizarre conclusions, improvised on, sung through, in order to make us recognize our contemporary environment, in order (and here his role is very much like that of a clown) to make us recognize ourselves in the parody of a distorting mirror.

Obviously, this shorthand view of Picasso oversimplifies, but it does, I think, go some way to explaining other facts about him: the element of caricature in all his work; the

extraordinary confidence behind every mark he makes – it is the confidence of the born performer; the failure of all his disciples – if he were a profoundly constructive artist this would not be so; the amazing multiplicity of his styles; the sense that, by comparison with any other great artist, any single work by Picasso seems unfinished; the truth behind many of his enigmatic statements: 'In my opinion, to search means nothing in painting. To find is the thing.' 'To me there is no past or future in art. If a work of art cannot live always in the present it must not be considered at all.' Or, 'When I have found something to express, I have done it without thinking of the past or the future.'

* * *

The tragedy of Picasso is that he has worked at a time when a few live by art alone and the vast majority live without art at all. Such a state of affairs is of course tragic for all artists – but not to the same extent. Certain painters – such as Cézanne, Degas, Gris – can work for the sake of research. They work to extend painting's conquest over nature. Picasso is not such an artist; it is significant, for instance, that for over forty years he has scarcely ever worked directly from a model. Other painters – such as Corot, Dufy, Matisse – work to communicate a quintessence of pleasure and are comparatively satisfied if this pleasure is shared even by a few. Again, Picasso is not such an artist. There is a violence in everything he has done which points to a moral, didactic conviction that cannot be satisfied simply by an awareness of pleasure. Picasso is, as Rodin was in a different way, naturally a popular dramatic artist, terribly handicapped by a lack of constant popular themes.

Twentieth-century masters

What makes a work by Picasso immediately recognizable? It is not only his familiar formalizations but his unique form of conviction, of utter singlemindedness in any one canvas. Possibly that sounds a vague quality. Yet if one goes into a Romanesque church and sees side by side a twelfth- and an eighteenth-century fresco, it is this quality of singlemindedness which distinguishes them, when all the other obvious differences have been allowed for. The twelfth-century painter, if a local one, was usually clumsy, unoriginal and entirely ignorant of theoretical pictorial principles. The eighteenth-century painter was often sensitive, highly skilful in rendering an unlimited variety of poses and steeped in valid pictorial theory. What then explains the force of the twelfth-century artist's composition, the expressiveness of his drawing, the clarity of his narrative, and the comparative feebleness in all these respects of the later work? It is surely the earlier artist's singlemindedness – a singlemindedness which in terms of religion was impossible in the eighteenth century. Because the earlier artist knew exactly what he wanted to say – and it was something quite simple – it did not occur to him to think of anything else. This reduced observation to a minimum but it gave his work the strength of seeming absolutely inevitable. It is precisely the same quality which distinguishes Picasso's work from that of his contemporaries and disciples; or, on a quite different level, it is the same quality that one finds in the humorous drawings of Edward Lear.

Look at the drawing of the hands and feet in *Guernica*. They are based on no more penetrating observation than those in the work of an efficient cartoonist. They represent no more than the *idea* of hands and feet. But – and this is

why *Guernica* can still strike our hearts until we are forced to make resolutions – the ideas of hands, feet, a horse's head, a naked electric light bulb, a mother and ravaged child, are all equally, heartrendingly and entirely dominated by the *idea* of the painting: the idea of horror at human brutality.

I believe that in almost every work of Picasso's a single idea has dominated in this way and so created a similar sense of inevitability. If the idea is, for example, that of sexual beauty, it demands more subtle forms: the girl's back will be made to twist very sensitively: but the principle remains the same and rests on the same ability of the artist to forgo all questioning and to yield completely to his one purpose. Forms become like letters in an alphabet whose significance solely depends upon the word they spell. And that brings us back to the tragedy of Picasso. Obviously in the case of an artist such as I have described, his development within himself and his impact on others depend exclusively on his ideas, on his themes. Picasso could not have painted *Guernica* had it only been a personal nightmare. And equally, if the picture which now exists had always been called *Nightmare* and we knew nothing of its connection with Spain, it would not move us as it does. All aesthetes will object to that. But *Guernica* has deservedly become the one legendary painting of this century, and although works of art can perpetuate legends, they do not create them. If they could Picasso's problem would have been solved, for his tragedy is that most of his life he has failed to find themes to do himself justice. He has produced *Guernica*, *War* and *Peace*, some miraculous Cubist studies, some beautiful lyrical drawings, but in hundreds of works

he has, as a result of his singlemindedness, sacrificed every-thing to ideas which are not worthy of the sacrifice. Many of his paintings are jokes, either bitter or gay; but they are the jokes of a man who does not know what else to do except laugh, who improvises with fragments because he can find nothing else to build upon.

It would be foolish to imagine that Picasso could have developed differently. His genius is wilful and instinctive. He had to take what was at hand and the unity of popular feeling essential to sustain the themes of a dramatic artist such as he is, has often been lacking or beyond his horizon. He then faced the choice of either abandoning his energy or expending it on something trivial and so creating parodies.

I am sure he is aware of this. He is obsessed by the ques-tion of whether art, which as we understand it today is so conscious an affair, can ever be born of happiness and abundance instead of lack and loss. The immortal incom-plete artist beside the mortal complete man – this is one of his recurring themes. The sculptor chisels instead of enjoy-ing his model. The poet-lovers search for images in one another's eyes instead of each other. A woman's head is drawn in a dozen different ways, is almost endlessly im-provised upon, because no single representation can do her living justice. And then at other times, and particularly in the second half of his life, Picasso reverses his comment and comparison, and contrasts the artist's always new, fresh imagination with his ageing body. The old man and the young girl, Beauty and the Beast, Beauty and the Mino-taur: the theme of the self-same artist and man being unable to accept each other's roles.

Permanent Red

Yet finally why is it so impossible to end without saluting him? Because by his dedication to his great themes, by his constant extremism, by the audacity of his jokes, by his simplicity (which is usually taken for incomprehensibility), by his very method of working, he has proved that all the paraphernalia, all the formulae of art are expendable for the sake of the spirit. If we now take him too seriously we destroy his example by re-establishing all the paraphernalia he has liberated us from.

HENRI MATISSE

Matisse's greatness has been recognized but not altogether understood. In an ideological climate of anguish and nostalgia an artist who frankly and supremely celebrated Pleasure, and whose works are an assurance that the best things in life are immediate and free, is likely to be thought not quite serious enough. And indeed, in Matisse's obituaries the word 'charming' appeared too frequently. 'I want people who feel worried, exhausted, overworked, to get a feeling of repose when looking at my painting.' That was Matisse's intention. And now, looking back over his long life's work, one can see that it represents a steady development towards his declared aim, his works of the last fifteen or twenty years coming nearest to his ideal.

Matisse's achievement rests on his use – or in the context of contemporary Western art one could say his invention – of pure colour. The phrase, however, must be defined. Pure colour as Matisse understood it had nothing to do with abstract colour. He repeatedly declared that colour 'must serve expression'. What he wanted to express was

'the nearly religious feeling' he had towards sensuous life – towards the blessings of sunlight, flowers, women, fruit, sleep.

When colour is incorporated into a regular pattern – as in a Persian rug – it is a subsidiary element: the logic of the pattern must come first. When colour is used in painting it usually serves either as a decorative embellishment of the forms – as, say, in Botticelli – or as a force charging them with extra emotion – as in Van Gogh. In Matisse's later works colour becomes the entirely dominant factor. His colours seem neither to embellish nor charge the forms, but to uplift and carry them on the very surface of the canvas. His reds, blacks, golds, ceruleans, flow over the canvas with the strength and yet utter placidity of water above a weir, the forms carried along on their current.

Obviously such a process implies some distortion. But the distortion is far more of people's preconceived ideas about art than of nature. The numerous drawings that Matisse always made before he arrived at his final colour-solution are evidence of the pains he took to preserve the essential character of his subject whilst at the same time making it 'buoyant' enough to sail on the tide of his colour scheme. Certainly the effect of these paintings is what he hoped. Their subjects invite, one embarks, and then the flow of their colour-areas holds one in such sure equilibrium that one has a sense of perpetual motion – a sense of movement with all friction removed.

Nobody who has not painted himself can fully appreciate what lies behind Matisse's mastery of colour. It is comparatively easy to achieve a certain unity in a picture either by allowing one colour to dominate or by muting all

the colours. Matisse did neither. He clashed his colours together like cymbals and the effect was like a lullaby.

Perhaps the best way of defining Matisse's genius is to compare him with some of his contemporaries who were also concerned with colour. Bonnard's colours dissolve, making his subjects unattainable, nostalgic. Matisse's colours could hardly be more present, more blatant, and yet achieve a peace which is without a trace of nostalgia. Braque has cultivated his sensibility until it has become precious. Matisse broadened his sensibility until it was as wide as his colour range, and said that he wanted his art to be 'something like a good armchair'. Dufy shared Matisse's sense of enjoyment and his colours were as gay as the fêtes he painted; but Matisse's colours, no less bright, go beyond gaiety to affirm contentment. The only man who possibly equals Matisse as a colourist is Léger. But their aims are so different that they can hardly be compared. Léger is essentially an epic, civic artist; Matisse essentially a lyrical and personal one.

I said that Matisse's paintings and designs of the last fifteen years were his greatest. Obviously he produced fine individual works before he was seventy. Yet not I think till then had he the complete control of his art that he needed. It was, as he himself said, a question of 'organizing the brain'. Like most colourists he was an intuitive painter, but he realized that it was necessary to select rigorously from his many 'instincts' to make them objective in order to be able to build upon them rationally. In terms of the picture this control makes the all-important difference between recording a sensation and re-constructing an emotion. The Fauves, whom Matisse led, recorded sensa-

tions. Their paintings were (and are) fresh and stimulating, but they depended upon and evoke a forced intoxication. When Matisse painted red flashes against ultramarine and magenta stripes to describe the movement of goldfish in a bowl, he communicated a pleasurable shock; one is brought up short by the climax but no solution follows. It was for this reason, I think, that Matisse finally abandoned Fauvism and returned to a more disciplined form of painting. Between 1914 and 1918 he produced paintings – mostly interiors – which are magnificently resonant in colour, but in which the colours seem *assembled* rather than dynamic – like the furnishings in a room. Then for the next ten years he painted his famous Odalisques. In these the colour is freer and more pervasive, but, being based on a heightening of the actual local colour of each object, it has a slightly exotic effect. This period, however, led him to his final great phase: the phase in which he was able to combine the energy of his early Fauve days with a quite objective visual wisdom.

It is of course true that Matisse's standards of imagination and taste belonged to the world of the French *haute bourgeoisie*. No other class in the modern world enjoyed the kind of seclusion, fine taste and luxury that are expressed in Matisse's work. It was Matisse's narrowness (I can think of no modern artist with less interest in either history or psychology) that saved him from the negative and destructive attitudes of the class-life to which his art belonged. It was his narrowness that allowed him to enjoy this milieu without being corrupted by it, or becoming critical of it. He retained throughout his whole career something of Veronese's naive sense of wonder that life could be so rich

and luxurious. He thought and saw only in terms of silks, fabulous furnishings, the shuttered sunlight of the Côte d'Azur, women with nothing to do but lie on grass or rug for the delight of men's calm eyes, flower-beds, private aquaria, jewellery, couturiers and perfect fruit, as though such joys and achievements, unspoilt by mention of the price, were still the desire, the ambition of the entire world. But from such a vision he distilled experiences of sensuous pleasure, which, disassociated from their circumstances, have something of the universal about them.

DUFY

Dufy almost defies serious criticism. Gaiety and analysis cannot go hand in hand. Ask, 'Are you really happy?' or 'Why are you so happy?' and the happiness is diffused. He has been compared to Mozart. But that is as exaggerated as it is silly to regret that he was not a Beethoven. Dufy took a lot of trouble to hide his skill and any evidence of struggle in his work; he knew that enchantment must almost seem spontaneous and that decorations should delight rather than provoke 'profound admiration'. Now that he is a dead master, his apologists take almost as much trouble to point out that he was not really a superficial artist and that a great deal of knowledge and craftsmanship lay behind his 'effortless' canvases. Yet really that is not necessary, for Dufy hasn't got to be justified. No justification will convince the artistic and political Calvinists who disapprove of him. And he himself laid no great claims. 'I started out with the smallest of ideas. How hard I have had to work before I shed my husk.'

He was not a draughtsman. If one looks at the 1900 portrait of his brother as a bandsman, and then at his 1950 version of the same picture, one sees that even after fifty years' experience of painting he didn't bother to correct the weak drawing of the hand. He was not an intellectual painter. His early Cubist works lack any rational investigation of form. He was not really even a Fauve; his fauvist pictures were not predatory enough. He was simply, frankly, zestfully, an entertainer, and the visual equivalent of entertainment is decoration. His sketch for a swimming-bath mural in the *Normandie* and his huge panel of the History of Electricity for the 1937 Paris exhibition show what a natural decorator he was. The placing of each 'diffusion' of colour seems as apt and happy an accident as a fine day for the opening. They celebrate their own occasions and nothing more – like a frieze of live flowers. Electricity is the world lit up: the swimming-pool *décor* an Undine invitation to the dance.

The tragedy of Dufy was that in our 'age of anxiety' he was not used every month to design for pageants, processions, public holidays. As it was, he watched them – such as they were – and painted pictures *of* them: the regattas, the races, the receptions, the concerts, the casino parties, the *fêtes*. Probably these pictures are far happier than were the occasions themselves, for Dufy understood the value of the transient. He knew that delight must be immediate. And so he worked out a visual shorthand to save – not so much time – as any appearance of meditation. He used oil paint like water colour (his whites look like the white of the paper) in order to emphasize the volatility of light and of his own reactions. A brush mark of white on green, a

squiggle and a blob near it, and, hey presto! you have a cabbage white; another, and you have a sail on the sea, yet another, a *débutante* at a dance. To look at a good picture by Dufy is like being blindfolded, led to somewhere in the sunlight, and suddenly having your eyes unbandaged: the dazzle of light, the surprise of vision itself then confound all precise logic. Which is, perhaps, also a way of describing the essence of gaiety. Dufy's vision was not profound, but his gaiety was.

KOKOSCHKA

Kokoschka's genius is difficult to define. On the one hand, it is sensible to compare him with Rubens – not necessarily in stature, but temperamentally, because he has the same kind of scale as a painter. Like Rubens, he has painted panoramic landscapes which the light visits like an archangel at an Annunciation. Like Rubens, he glories in exotic animals and fruits, seeing them as symbols of various kinds of human power. Like Rubens, he paints human flesh as though it were a garden and each brushmark a blossom. And, like Rubens too, he is immensely confident, never failing through diffidence, but sometimes through abundance becoming chaos. Yet on the other hand, Kokoschka is a man of the twentieth century. He has not created a new language or a new form of art. What he has done is to speak with great authority in an unforgettable tone of voice – always remembering that for an artist his tone of voice is inseparable from what he has to say:

All life is a risk, but that is no reason for panic. In the normal course of things it ends in death; only in the Académie

Française are immortals to be found. But to anyone who is clear about the risks of life and learns to confront them with open eyes, the inscrutable, humanized in art form, becomes comprehensible and thus loses its terror.

Kokoschka is usually labelled an Expressionist. This is misleading, because since he is often considered as a German painter, it means that he is bracketed with other German expressionists, whereas his aim, unlike theirs, was to reduce, not to parade, panic. It is also usually said that his early work is stronger than his later work, but this judgment springs from the same misconception: that he is essentially an artist of conflict and pain. In fact, his constant theme is something quite different – energy. In his earlier works, up to about 1920, he was concerned, mostly in portraits, with what is roughly called nervous energy. The spirits of his sitters crackle like lightning, and their hands, with their outstretched fingers, often look like trees that have just been struck. Later he was concerned, in his large panoramic views, with the energy of cities – with what might be called historical energy. Still later he turned to ancient legends to find themes which embodied the energy of the cycle of life itself.

But of course the word energy is too vague and too abstract to define the character of Kokoschka's achievement and searching. It makes it easy to understand why he has turned to baroque artists for help, but it does not explain why his voice has such authority, why he is so surely a modern artist.

Energy means for him movement and development. In his portraits one has the sense that the sitter has been painted, unawares, whilst on a journey, not necessarily a

physical journey, but a journey of thoughts and decisions, which is going to change – which indeed at that very moment is changing – his life. In our century of crisis these are, in this sense, the most precarious portraits painted, and in that precariousness we recognize ourselves. How often in his panoramic landscapes he includes a river or, as an important not an incidental element in the picture, birds in the sky; and these again suggest voyaging, movement, time passing. In his recent large triptychs his concern with development, with consequences, is even more obvious, for here he has painted consecutive incidents from a story – the story of Prometheus or the story of the Greeks defending Thermopylae.

Kokoschka did not of course arbitrarily select this constant theme. It has arisen from his experience. As a mid-European born in 1886, he has seen much. And he has never been a passive spectator or a remote studio man. He has prophesied and committed himself. He is acutely aware of the way our European societies alienate man from man (and incidentally believes abstract art to be a symptom of this alienation):

> That technical civilization, in which we have all collaborated, has been throughout two world wars nothing but an attempt to escape disaster by means of an intensified production for the mere sake of production, and the effort is shown to be all the more senseless as the numbers of the homeless, the desperate and the starving roaming over the untilled fields of the world increase.

Consequently he has searched for a way forward, a way of release. The emotion behind most of his work is liberating. The figures, the animals, the cities in his canvases are set

free: the skies around them are like those endlessly imagined by a prisoner. His richness and abundance is not luxurious as in true baroque art, rather it represents a kind of innocence. Not that he is a Utopian artist. His aim is simply to make us see what we are capable of, to warn us against accepting the idea that all circumstances are final.

His weakness as a painter is that he is sometimes formlessly effusive. This may be the result of the fact that he blames technology itself for our predicament, so that his positive alternative becomes an unselective all-embracing humanism. If he were more aware of the economic and social basis of history, his hopes might be sharper and less generalized. Nevertheless we can only honour. He has confronted our situation with open eyes and has never retreated into cynicism, nihilism or morbid subjectivity: his genius has remained expectant. Having borne witness to great suffering, he still, at the age of over seventy, believes with Blake that 'Exuberance is Beauty'.

The life and death of an artist

He is an old, very tall, thin man. His face is that of an old, tall, upright man; no literary image should be used to describe the face of this life-long image maker. And when I told him, thinking of how many tinkers, and horse traders and wanderers he had painted, that Léger had said that the artist was in the same class as the *clochard*, because in their common desire for the danger of maximum freedom they backed the same horse, the only difference being that the artist won and the *clochard* lost – when I told him this, he smiled, sharing his own experiences with himself, and added like an old man, and exactly like an old man and nothing else – except that he was attentive enough to nod at the speed with which I was drinking his Irish whiskey – he added, 'Yes, but some of the best people are losers. I've known some terrible brilliant men – all brilliance on the outside, and all morality inside, as a second line of defence.'

How he hates morality, this octogenarian. For him morality is a foreign imposition brought on the point of the bayonet. A romantic conception? But this man is one of the last living romantics – not because he is still alive, but because he lives his philosophy. On the periphery of the twentieth century, he has challenged Thoreau's nineteenth-century remark, 'It is now noble to profess because it was once noble to live.' He has not played with the light effects so that the critics, goggling, search for the right word, earn

their money by their hard struggle, and eventually spell
out the label Romanticism; he is a romantic who has
always walked out into the darkness, so that when he meets
his travellers there is no need to portray them in fancy
dress, for they already wear all that he has imagined in his
own previous dark solitary journey. When a man advances
into a cave, the dark winds round his throat and trails
behind him like a scarf. When a girl stands on the shore,
look how the sea becomes her – in both palpitating senses
of that word *become*. When soldiers are seen striking camp
for the *second* time, all movements are automatic and even
the dawn is tarnished, because 'supposing you know you
must die at dawn and you prepare yourself, and supposing
you are reprieved and then have to face another dawn
with the same knowledge – that is hard indeed.'

No one has ever been allowed to watch him paint. Be-
fore his wife died he used to take a white pipe-cleaner –
'like a sheep's leg' – and bend it into a circle and put it
on the knob of his studio door to warn her that he was at
work. A question of professional secrets? No, a question of
his being desperately – and to us rational materialists,
almost incomprehensibly – anxious that he might not be
able to rediscover his own secrets. 'And Carlyle,' he laughs,
'thought ninety-nine per cent of genius was taking pains.
I am sure now his poor wife had something to say about
that. A painting is an event. And that's what that old
Gamp Fry – do you still read him? – a grey-minded man
and a timid painter, too – that's what he never understood.
You can plan events, but if they go according to your plan
they are not events.'

I disagreed with him about art being amoral and said

that I thought the artist had a moral obligation: namely, to identify himself to the full with his subject.

His reply was to fill up my glass, refocus his eyes and tell me about his subjects. He sang 'The boy I love is in the gallery' with Marie Lloyd, he showed me with his long, thin hands the secrets of the grabbing, conjuring tricks plied at the horse fairs, he fought old fights in the ring, he brought in a horse suspiciously offered for sale in the middle of the night, and examined it with a lantern, he kept a late rendezvous in the East India Docks, and then coming back to my point he said: 'Maybe. But too many moral people expect you to be respectful to your subjects. And how can you be that if you identify yourself with them? And then these same people come along and ask you, "How long did it take you to do that painting?" and if you say months, they think it's worth a lot. That's morality for you.'

Referring to Jack Yeats's paintings, Samuel Beckett wrote, 'He grows Watteauer and Watteauer.' That is a perceptive stimulating remark. The differences are obvious: the folds in the silk have become tears in rough cloth: the artificial gestures of the *fête* in the enclosed garden have become the so similar but *naturally* exaggerated gestures with which travellers greet each other on a deserted open plain. The nervousness of the technique has become magnified, as though one square centimetre of Watteau were painted to the scale of a square foot: Yeats is coarser – and gayer. But their subjects – transience, mortality – are the same, and, although Watteau's vision was melancholically ironic and Yeats's, just because it is coarser, is heroic – death for him is the condition for human consciousness and therefore for freedom – there has been no artist between

these two who has specifically dealt with the same subject so poignantly and unsentimentally.

Thus Yeats's theme is universal. That is not to say that his works would fit easily into the modern cosmopolitan museum. They would not, for the works which are pre-fabricated for that museum are by artists who prefer to 'profess' rather than live. And it is because Yeats realizes that this profession of being all things to all men means the denial of living art, that he has always refused to allow his work to be reproduced in colour and bound in sumptuous volumes. The fact that he has consequently lost inter-national recognition means less to him than the fact that each painting is an event – a single event. And when publishers have promised him the most accurate and faithful reproductions, he has replied: 'The better they are the worse they are.'

Like all artists who achieve a degree of universality, Yeats is closely bound with the local and particular. Cézanne seems formalized until one has seen Provence through his eye. Yeats seems too 'mobile', over-spontaneous, until one has watched the west coast of Ireland. And watched is the word, for the landscape there is a fast series of events, not a view – an unchanging structure. The land is as passive as a bog can be. The sky is all action. I am told that the sky is similar in California, and perhaps along any ocean coast facing west. But in Ireland the sky is a dancer, tender and wild alternately, and then furious, ripping her clothes and parading her golden body to get just one glimmer of res-ponse from the peat. And she gets it. For in the ruts and bog puddles and along the wet shoulders of a tarpaulin the water flashes back, seeming by contrast with its surround-

ings even brighter than her. And it is this wild dancing and wilder response that Yeats has painted. This is how the green lying on a distant hill is pulled, by the sheer movement of a foreground head turning, into that head's eyes, whilst the miles between the head and the hill remain. This is how a red streak in the sky becomes the gauntlet of a rider and the belly of his horse below.

Not that Yeats has ever been a literal landscape painter. He transforms everything within his imagination. And if I had to give a single reason why I believe he is a great painter I would cite the consistency of this power of his to transform. Like Giorgione or Delacroix, he can cast his spell even over the foreground of his pictures. Most modern romantics because they do not live their philosophy can never bring their romantic vision nearer than the middle distance: the foreground simply remains a frame. Yeats – and in this he is unlike his brother – has never stepped out of his vision. He has continued to embrace mortality in the face of every moral warning. But he has been able to do this because his vision has its roots in his country: visually in the Irish landscape: poetically in Irish folklore: and ideologically in the fact that Ireland has only up to now been able to fight English imperialism with the image of the independent individual Rebel.

*　*　*

Jack Yeats is now dead. For those who are at all aware of an artist as a man his paintings change after his death. Whilst he is alive all his works even those that are declared finished, are seen to some extent as works in progress; as you look at them you relate them to an

imagination that still exists and is still working; his works then chart a progress. After his death they become final and definitive; they no longer chart his progress, they gather together to form his destination. In Dublin I wanted to ask Yeats about his paintings. Today similar questions do not even come to mind. The living artist is either more or less open to intervention, persuasion, influence, questioning, which is why his work can have an urgency for us which is different in kind from anything we can get from works of the past. From them we can only learn. There is thus a logic in the fact that only when an artist is dead can he be fully recognized as a master. While he is alive he can, of course, be recognized as great, as a source of understanding and inspiration, but this is different, for our relationship with him then cannot be purely a pupil-teacher one: we are also related to him by a hundred and one other mutual responsibilities because both he and we are alive. Yeats has now become a master.

Very many of Yeats's last pictures are implicitly, but not explicitly, concerned with death. *Sleep Sound:* two figures lie on a moor, the sky above them heavy as the breathing of those who might keep their wake. *The Hour of Sleep:* a man nods in a mountain field of gentians and behind him is a monolithic, immovable, dead block of stone. *The Nights are Closing In:* two figures talk against a sky being torn to tatters. *Tir-na-n-Og:* which means the country where neither age nor death exists and where the Irish peasant believes 'you will get happiness for a penny'.

How is it then, the reader may ask, that I, a Marxist, can find so much truth and splendour in the art of an arch-romantic such as Yeats? Professor George Thomson has

already answered this question by quoting the painter's brother:

Sing on: somewhere at some new moon,
We'll learn that sleeping is not death,
Hearing the whole earth change its tune.

What, in other words, we have in common with the genuine romantic is a sense of the future, an awareness of the possibility of a world other than the one we know. (I say *genuine* romantic to distinguish men like Yeats or Géricault, who lived their romanticism, from those who merely use romantic poses.) Strange as it may sound, no European country had until recently a greater sense of the future than Ireland. This was partly because no bourgeoisie had destroyed its popular art, which was an art of longing, and partly because its colonial status bred rebels. Even the fairies, the ghosts, the banshees, the famous songs, the notorious and magnificent edifices of words that could be built in a few moments out of nothing, were partly expressions of an Irish conviction that there was something beyond the facts of that poverty which quite simply halved their population in the second half of the nineteenth century. Even today the IRA flickers with something of the same spirit. Ireland has not yet reached that critical point where she can only defend her way of life: she is still striving, staggering, suffering and dreaming towards one. And however much the keep-art-pure-sirs may hate it, it is impossible to appreciate Yeats fully without understanding something of this.

It is this which explains how Yeats was a modern painter – he had no nostalgia for the art styles of the past – and yet

was apparently quite uninfluenced by Cubism and Abstract art. It is also this which explains why his work, which is expressionist in character, is nevertheless quite free from the sense of personal desperation found in mid-European Expressionism. (In this Yeats resembles the Indonesian painter, Affandi, and it may well be that this kind of romantic but outward-facing expressionism is the natural style of art for previously exploited nations fighting for independence – modern classicism requires an industrial society.) Yeats's romantic view of life brought him closer to his subjects – his horsemen, actors, lovers, talkers, beggars – instead of separating him from them. His paintings, as opposed to the landscapes they include, do not convey loneliness; on the contrary, they appear to be made out of the stuff of legends that have been as much handled and commonly slept in as the blankets on the inn's bed for travellers. Further, it is Yeats's Irish background which explains why his direct influence on younger European painters would be a dangerous one, leading to theatrical mannerism.

What his background cannot directly explain is Yeats's pictorial genius as a painter: his sense of colour, like a Venetian's, but derived from rags and a lean shimmering world, instead of from velvets and mellow feasts: his draughtsmanship, nervous, spontaneous – sometimes achieved, I suspect, by painting with the very nozzle of the tube of pigment, occasionally becoming incoherent, but at its best describing forms breaking against the surface of the mist, the dusk, the sunlight, like fishes breaking the surface of water as they leap across it: his sense of pictorial unity, so that for all the shreds of colour and the shimmer and the

speed, his canvases as a whole are permanently calm.

Both Yeats's pictorial genius and his spirit can be epito-
mized by a small canvas called *The First Away*. It represents
simply a man's head and shoulders against the sky. The
way in which the smooth milky surface of the sky and the
curdled paint describing the man's features are held to-
gether in unity is a miracle of tonal and colour adjustment,
as refined as any passage in Braque. As for the content: the
man's eyes in his pale shriven face are closed in rapture. Is
it he or is it the horse who is first away? And away to
where?

To where:

> *Delight makes all of the one mind,*
> *The riders upon the galloping horses*
> *The crowd that closes in behind.*

Now that he is dead, Yeats has become a master: he
teaches us to hope.

Lessons from the past

All appreciation of the art of the past is one-sided and to some extent distorted. Above all the art of the past gives us a sense of false security. It offers too easy a confirmation of the continuity of human culture. A work from the past becomes an heroic object of its period and so falsely implies that the hero inevitably wins through. We recognize the qualities of the work, its energy, unity, humanity – and these we find inspiring – but we are not inevitably involved in the means by which such qualities have been achieved. We are not involved, as we would be before a contemporary work, in the price paid for its aspiration, in stirrings of conscience, in the effort needed to look at new things in a new way, in the possibly urgent associations of the subject, in what amounts to the *plea* of the work.

I know that to all those who believe that greatness in art is entirely a matter of form, this will seem quite absurd. 'What do you mean by a work making a plea?' they will ask.

I would counter that question with another – a hypothetical one.

Imagine the masterpieces (in any medium) of the future, say those produced in one hundred years' time. If form was the heart of the matter of appreciation, and if by some trick of time we were able to see, read or hear these works now, we would easily be able to appreciate them. Yet in fact

would they really mean anything to us? I cannot believe that they would.

But this is not primarily to dispute the argument of the formalists. It is to emphasize that art is *not* timeless and eternal. Great works survive their period, but that is not to say that they do not die. After their period they live again by virtue of a sort of resurrection. This after-life, however, is never the same intense, committed thing as their original life.

If this is true, one can better understand the horrific absurdity of artists consciously working for the future – 'I shall only be properly appreciated in a hundred years' time.' This is to combine simultaneously birth and death: to produce still-born works. Equally one can better understand the feebleness of so much contemporary work which has relied upon the art of the ancient past for its *direct* inspiration: Academic art deriving from Greece: 'Modern' art deriving from Peru, Africa, Pompeii, Etruria.

We must recognize that there is such a thing as the natural death of a work of art. Nor is it morbidity that makes me say this is a recognition we should celebrate. Only if we recognize the mortality of art, shall we cease to stand in such superstitious awe of it – only then shall we consider art expendable and so have the courage to risk using it for our own immediate, urgent, only important purposes.

Lessons from the past

THE CLARITY OF THE RENAISSANCE

It's depressing. The rain's set in. It's wet but we can't grumble. It's grey and dull. Each of these comments describes the same day from a different point of view: the subjective, the practical, the moralistic and the visual. All true painters naturally see and feel in a way that is a hundred times more acutely visual and tangible than the last, or indeed any comment, can illustrate. But what they see and feel is – normally – the same as everybody else. To say this is, I realize, platitudinous. But how often it is forgotten. Indeed, has it ever been consistently taken for granted since the sixteenth century?

I spent the other day in the National Gallery looking mainly at the Flemish and Italian Renaissance works. What is it that makes these so fundamentally different from nearly all the works – and especially our own – that have followed them? The question may seem naive. Social and stylistic historians, economists, chemists and psychologists have spent their lives defining and explaining this and many other differences between individual artists, periods and whole cultures. Such research is invaluable. But its complexity often hides from us two simple, very obvious facts. The first is that it is our own culture, not foreign ones, which can teach us the keenest lessons: the culture of individualist humanism which began in Italy in the thirteenth century. And the second fact is that, at least in painting, a fundamental break occurred in this culture two and a half centuries after it began. After the sixteenth century artists were more psychologically profound (Rem-

brandt), more successfully ambitious (Rubens), more evocative (Claude); but they also lost an ease and a visual directness which precluded all pretension; they lost what Berenson has called 'tactile values'. After 1600 the great artists, pushed by lonely compulsion, stretch and extend the range of painting, break down its frontiers. Watteau breaks out towards music, Goya towards the stage, Picasso towards pantomime. A few, such as Chardin, Corot, Cézanne, did accept the strictest limitations. But before 1550 every artist did. One of the most important results of this difference is that in the great later forays only genius could triumph: before, even a small talent could give profound pleasure.

I am not advocating a new Pre-Raphaelite movement, nor am I making any qualitative judgment – in the broadest human sense – of the art of the last three and a half centuries. But now when so many artists tend – either in terms of technique or subjective experience – to throw themselves vainly against the frontiers of painting in the hope that they will be able to cut their own unique individual passes, now when the legitimate territory of painting is hardly definable, I think it is useful to observe the limitations within which some of the greatest painters of our culture were content to remain.

When one goes into the Renaissance galleries, it is as if one suddenly realized that in all the others one had been suffering from a blurred short-sightedness. And this is not because many of the paintings have been finely cleaned, nor because chiaroscuro was a later convention. It is because every Flemish and Italian Renaissance artist believed that it was his subject itself – not his way of painting it –

which had to express the emotions and ideas he intended. This distinction may seem slight but it is critical. Even a highly mannered artist like Tura convinces us that every woman he painted as a madonna actually had doubly sensitive, double-jointed fingers. But a Goya portrait convinces us of Goya's own insight before it convinces us of his sitter's anatomy; because we recognize that Goya's interpretation is convincing, we are convinced by his subject. In front of Renaissance works the exact opposite occurs. After Michelangelo the artist lets us follow him; before, he leads us to the image he has made. It is this difference – the difference between the picture being a starting-off point and a destination – that explains the clarity, the visual definitiveness, the tactile values of Renaissance art. The Renaissance painter limited himself to an exclusive concern with what the spectator could see, as opposed to what he might infer. Compare Titian's *presented* Venus of Urbino of 1538 with his elusive Shepherd and Nymph of thirty years later.

This attitude had several important results. It forbade any attempt at literal naturalism because the only appeal of naturalism is the inference that it's 'just life like': it obviously isn't, in fact, like life because the picture is only a static image. It prevented all merely subjective suggestibility. It forced the artist, as far as his knowledge allowed him, to deal simultaneously with all the visual aspects of his subject – colour, light, mass, line, movement, structure, and not, as has increasingly happened since, to concentrate only on one aspect and to infer the others. It allowed him to combine more richly than any later artists have done realism and decoration, observation and formaliza-

tion. The idea that they are incompatible is only based on today's assumption that their inferences are incompatible; visually an embroidered surface or drapery, *invented* as the most beautiful mobile architecture ever, can combine with realistic anatomical analysis as naturally as the courtly and physical combine in Shakespeare.

But, above all, the Renaissance artist's attitude made him use to its maximum the most expressive visual form in the world – the human body. Later the nude became an idea – Arcadia or Bohemia. But during the Renaissance every eyelid, breast, wrist, baby's foot, nostril, was a double celebration of fact: the fact of the miraculous structure of the human body and the fact that only through the senses of this body can we apprehend the rest of the visible, tangible world.

This lack of ambiguity is the Renaissance, and its superb combination of sensuousness and nobility stemmed from a confidence which cannot be artificially re-created. But when we eventually achieve a confident society again, its art may well have more to do with the Renaissance than with any of the moral or political artistic theories of the nineteenth century. Meanwhile, it is a salutary reminder for us even today that, as Berenson has said so often and so wisely, the vitality of European art lies in its 'tactile values and movement' which are the result of the observation of the 'corporeal significance of objects'.

Lessons from the past

THE CALCULATIONS OF PIERO

After reading Brecht's *Galileo* I was thinking about the scientist's social predicament. And it struck me then how different the artist's predicament is. The scientist can either reveal or hide the facts which, supporting his new hypothesis, take him nearer to the truth. If he has to fight, he can fight with his back to the evidence. But for the artist the truth is variable. He deals only with the particular version, the particular way of looking that he has selected. The artist has nothing to put his back against – except his own decisions.

It is this arbitrary and personal element in art which makes it so difficult for us to be certain that we are accurately following the artist's own calculations or fully understanding the sequence of his reasoning. Before most works of art, as with trees, we can see and assess only a section of the whole: the roots are invisible. Today this mysterious element is exploited and abused. Many contemporary works are almost entirely subterranean. And so it is refreshing and encouraging to look at the work of the man who probably hid less than any other artist ever: Piero della Francesca.

Berenson praises 'the ineloquence' of Piero's paintings:

> In the long run, the most satisfactory creations are those which, like Piero's and Cézanne's, remain ineloquent, mute, with no urgent communication to make, and no thought of rousing us with look or gesture.

This ineloquence is true so far as Piero's protagonists are

157

concerned. But in inverse ratio to how little his paintings say in terms of drama, they say volumes about the working of his own mind. I don't mean they reveal his psychology. They reveal the processes of his conscious thought. They are open lessons in the logic of creating order. And possibly the inverse ratio exists because, just as the aim of the machine is economy of effort, the aim of systematic thought is economy of thought. Anyway it remains true that before a Piero you can be quite sure that any correspondence or coincidence which you discover is deliberate. Everything has been calculated. Interpretations have changed, and will change again. But the elements of the painting have been fixed for good and with comprehensive forethought.

If you study all Piero's major works, their internal evidence will lead you to this conclusion. But there is also external evidence. We know that Piero worked exceptionally slowly. We know he was a mathematician as well as a painter, and that at the end of his life, when he was too blind to paint, he published two mathematical treatises. We can also compare his works to those of his assistants: the works of the latter are equally undemonstrative, but this, instead of making them portentous, makes them lifeless. Life in Piero's art is born of his unique power of calculation.

This may at first sound coldly cerebral. However, let us look further – at the *Resurrection* in Piero's home town of San Sepolcro. When the door of the small, rather scruffy municipal hall is first opened and you see this fresco between two fictitious, painted pillars, opening out in front of you, your instinct is somehow to freeze. Your hush has nothing to do with any ostentatious reverence before art or

Christ. It is because looking between the pillars you become aware of time and space being locked in a perfect equilibrium. You stay still for the same reason as you do when you are watching a tight-rope walker – the equilibrium is that fine. Yet how? Why? Would a diagram of the structure of a crystal affect you in the same way? No. There is more here than abstract harmony. The images convincingly represent men, trees, hills, helmets, stones. And one knows that such things grow, develop and have a life of their own, just as one knows that the acrobat can fall. Consequently, when here their forms are made to exist in perfect correspondence, you can only feel that all that has previously occurred to them, has occurred in preparation for this presented moment. Such a painting makes the present the apex of the whole past. Just as the very basic theme of poetry is that of time passing, the very basic theme of painting is that of the moment made permanent.

This is one of the reasons why Piero's calculations were not so cold, why – when we notice how the left soldier's helmet echoes the hill behind him, how the same irregular shield-shape occurs about ten times throughout the painting (count them), or how Christ's staff marks in ground plan the point of the angle formed by the two lines of trees – why we are not merely fascinated but profoundly moved. Yet it is not the only reason. Piero's patient and silent calculations went much further than the pure harmonies of design.

Look, for instance, at the overall composition of this work. Its centre, though not of course its true centre, is Christ's hand, holding his robe as he rises up. The hand furrows the material with emphatic force. This is no casual

gesture. It appears to be central to Christ's whole upward movement out of the tomb. The hand, resting on the knee, also rests on the brow of the first line of hills behind, and the folds of the robe flow down like streams. Downwards. Look now at the soldiers so mundanely, so convincingly asleep. Only the one on the extreme right appears somewhat awkward. His legs, his arm between them, his curved back are understandable. Yet how can he rest like that just on one arm? This apparent awkwardness gives a clue. He looks as though he were lying in an invisible hammock. Strung from where? Suddenly go back to the hand, and now see that all four soldiers lie in an invisible net, trawled by that hand. The emphatic grip makes perfect sense. The four heavy sleeping soldiers are the catch the resurrecting Christ has brought with him from the underworld, from Death. As I said, Piero went far beyond the pure harmonies of design.

There is in all his work an aim behind his calculations. This aim could be summed up in the same way as Henri Poincaré once described the aim of mathematics:

> Mathematics is the art of giving the same name to different things. . . . When language has been well chosen one is astonished to find that all demonstrations made for a known object apply immediately to many new objects.

Piero's language is visual, not mathematical. It is well chosen because it is based on the selection of superb drawing. Nevertheless, when he connects, by means of composition, a foot with the base of a tree, a foreshortened face with a foreshortened hill, or sleep with death, he does so in order to emphasize their common factors – or, more

accurately still, to emphasize the extent to which they are subject to the same physical laws. His special concern with space and perspective is dependent on this aim. The necessity of existing in space is the first common factor. And this is why perspective had so deep a *content* for Piero. For nearly all his contemporaries it remained a technique of painting.

His 'ineloquence', as already hinted, is also connected with the same aim. He paints everything in the same way so that the common laws which govern them may be more easily seen. The correspondences in Piero's works are endless. He did not have to invent them, he only had to find them. Cloth to flesh, hair to foliage, a finger to a leg, a tent to a womb, men to women, dress to architecture, folds to water – but somehow the list misses the point. Piero is not dealing in metaphors – although the poet in this respect is not so far removed from the scientist: he is dealing in common causes. He explains the world. All the past has led to this moment. And the laws of this convergence are the true content of his art.

Or so it seems. But in fact how could this be possible? A painting is not a treatise. The logic of its measuring is different. Science in the second half of the fifteenth century lacked many concepts and much information which we now find necessary. So how is it that Piero remained convincing, whilst his contemporary astronomers have not?

Look again at Piero's faces, the ones that watch us. Nothing corresponds to their eyes. Their eyes are separate and unique. It is as though everything around them, the landscape, their own faces, the nose between them, the hair above them, belonged to the explicable, indeed the

already explained world: and as though these eyes were looking from the outside through two slits on to this world. And there is our last clue – in the unwavering, speculative eyes of Piero's watchers. What in fact he is painting is a state of mind. He paints what the world would be like if we could fully explain it, if we could be entirely at one with it. He is the supreme painter of *knowledge*. As acquired through the methods of science, or – and this makes more sense than seems likely – as acquired through happiness. During the centuries when science was considered the antithesis of art, and art the antithesis of well-being, Piero was ignored. Today we need him again.

Lessons from the past

THE SWEET POWER OF FASHION

Louis XIV to his own Academy: 'I entrust to you the most precious thing on earth – my fame.'

From a purely historical point of view no work of art is absurd; it is simply a piece of evidence. But most men do not look at the art of the past from a purely historical point of view. They look with their present responsibilities in mind. It is not our philistinism but a sense of continuity and human progress that makes us conscious of absurdity. The present desperate eclecticism of taste is partly the result of disillusion. Given a positive belief in the future, one can afford to select more critically from the past.

I am not suggesting that one must make a wholesale moral condemnation of Louis's 'magnificent' despotism. Seventeenth-century France established the first modern, centralized, absolute state with all that that implies of progress from a medieval economy and culture. Yet we should not blind ourselves to the price paid for this advance: the directly human price, reflected, for instance, in the delight of the Parisian crowds at Louis's funeral, and the cultural price of absurdity.

The absurd works are never in bad taste. Indeed their absurdity lies partly in the contrast between their surface quality of style and their emotional emptiness. Time and again one sees how, when a painter is unfaithful to his experience in order to meet a conventional demand of the period's taste, his talents are betrayed. The tragic aspect of this is that the painter was probably quite unaware of his unfaithfulness.

Philippe de Champaigne would probably have been in-
credulous if he had been told that the classic severity of his
portrait of *Mère Agnès*, abbess of the Convent of Port-Royal,
can still move us – her podgy face and lumpy praying
hands, just withstanding the rhythmic uplift of her cowl
and sleeves; whilst his *Ecce Homo*, equally severe stylistically,
but unseen, contrived, looks to us now like something out
of Madame Tussaud's – how do they do those droplets of
blood?

It seems that in the period of individualist art – and the
seventeenth-century was the beginning of the period in
which we still live, when there is a basic opposition between
what is officially wanted and what the individual painter
may discover on his own – the great artist has to protect
himself by means of the severest self-knowledge. For Cara-
vaggio such knowledge was desperate, for Poussin it was
largely rational, for Rembrandt it was semi-mystical; it
can take many different temperamental forms, but with-
out it in some form, the artist is persuaded to become
unfaithful to his own experience without even realizing it.

Consider an early self-portrait of Simon Vouet. The
turbulent, Caravaggesque light flickers across the turbu-
lent face. It is not a great painting but it communicates
because it has a natural unity. The turbulence of both
style and vision perhaps derive in part from the same his-
torical process of disturbance, expressed and created,
among other things, by Copernicus's theory, the invention
of the telescope and Galileo's contemporary struggles. Then
consider his later and more baroque *Mary Magdalen*. It
still just works, although no longer in the way he intended.
The released, groundless, decorative energy of French

baroque is eminently suitable for expressing sexuality: the seduction is its natural subject. And so in Vouet's *Magdalen* there is still a flicker of truth to experience. All religious conviction has gone. But she is still just conceivably a prostitute. Then finally consider Vouet's *Christ on the Cross*. It might be a painting of a memento from Lourdes. The unfaithfulness is complete; absurdity has begun.

Even Louis and Mathieu Le Nain were deceived. Mathieu paints a young soldier playing cards. His tousled hair, his young open face full as a Flemish girl's in the lamplight, his metal breast-plate, the coarse stuff of his tunic, all these are an integral part of the painted moment during which he flings his card on to the tavern table. But when Mathieu paints the *Visitation*, the dramatic embrace of the two figures and the conventions of holiness utterly contradict the humble method of painting and one is reminded of clumsy actors dressed up in painted sacks at a village Nativity Play.

The reader may suspect that I am simply arguing for naturalist subjects as against mythological ones. But of course I am not and (apart from the whole Renaissance) Poussin proves it. Judged by the narrow criteria of daily prose, nearly all Poussin's paintings are absurd. Venus soars on a flying trapeze and Aeneas wears a hat that would bring the Palladium down. Yet Poussin's classicism was willed not commanded, and as a result the stage his figures walk upon is the field of his most profound experience. Formal gestures were as real to him as apples and mountains to Cézanne. Compare Poussin to Le Brun, whom Colbert chose as Louis's dictator of the arts, and the distinction becomes clear. Poussin, like a great dancer, ex-

presses all human potential by the movement and sequence of his figures; Le Brun, attempting the same thing, produces a farce that suggests policemen being suddenly called out from a fancy dress ball on to point duty.

Yet perhaps the most striking comparison of all is that between the art of Georges de La Tour and the art of Versailles. La Tour's painting of a woman sitting by candlelight, her bare feet on the floor, a night robe round her shoulders, her hair tied up in a scarf, the nipple of her bare breast no more remarkable then a stud in the back of the red chair beside her, killing a flea between her thumbnails, achieves a dignity comparable to that of a Piero or Van Eyck; whilst the portrait of a mistress of Le Roi Soleil now strikes us as the equivalent of an advertisement for a sleeping beverage, with the unimportant difference that the taste to which it appealed was more sophisticated. Nor is this puritanism directed against pleasure. As Marx said in a different context:

> Criticism has torn away the imaginary flowers with which his chains were bedecked, not in order that man should wear his chains without the comfort of illusions, but that he may throw off the chains and pluck the living flowers.

Most critics emphasize La Tour's 'detachment', and certainly his early canvases, painted somewhat in the manner of Velasquez, of an emaciated St Jerome and a blind *Hurdy Gurdy Player* are lucidly objective. Yet I doubt whether detachment is the right word to apply to his later works in which he uses the simplifying flare and darkness of candlelight to give his figures monumentality. Within the sheer gold-yellow and copper-vermilion forms that

make these figures look as though they are made of beaten metal (and the candle a welder's flame) like Gonzales's *Montserrat*, there is great, compressed emotion. Look, for example, at the hands. The hand of the child Christ against the candle-flame in Joseph's workshop - transparent as a leaf and childhood; Joseph's hands on the brace, like the feet of an ox; the hand of the woman who visits the Prisoner, just about to touch his head and baptise him with liberty; the hands of the Prisoner clenched together, like a flower that cannot open; the hands of the mother over the new-born child, like those of a master musician over a strange new instrument.

No, it is not detachment, but that disciplined severity which marks the essential self-knowledge I have already mentioned, and thus is also inevitably the characteristic of the greatest works in the individualist period of art. By being absolutely faithful to his own experience La Tour was able to transcend it - this is the only mystery in art - and so, when we look at his Prisoner, who for La Tour represented St Peter awaiting the angel, we can think, without the slightest incongruity, of Nazim Hikmet three hundred years later in a Turkish prison waiting for his wife.

> *The days are shortening*
> *The rains are going to start.*
> *My doors, wide open, waited for you.*
> *Why are you so late?*

Permanent Red

At Dulwich Art Gallery there are six Poussin canvases, and I recommend the reader to go there and study them under ideal conditions – it is quiet, the rooms are small and well-lit and one can think without being disturbed. And strange as it may seem, here – not in the endless volumes put out by the Museums of Modern Art – is the clue to all the best works created since Cézanne.

Take a picture like the *Nurture of Jupiter*. Are we still interested in a child god being suckled by a goat, in bees that made special honey for him and in Cretan nymphs? Hardly. Was even Poussin as interested as is often thought? A nymph, the Virgin Mary, a spectator of David's triumph over Goliath – each has the same face. So why are we moved? By the purely formal design? If that were so, we would be moved in the same way by, say, a Byzantine mosaic. Clearly we are not. No. In fact, it is here that we come to the first discovery: that in Poussin – and actually, though less obviously, in all art which survives its period – there is something between form and content arbitrarily divided: there is the way of looking at the world, the artist's method of selection, which the work in its entirety expresses and which is more profound than either its subject matter or its formal organization.

Poussin offers us the world as an impossibly honest trader. Everything on show is declared and defined without the slightest ambiguity. One can see on what every foot stands, what every finger touches. Compare his large tree with the trees in Claude next door. Claude's are far

168

truer to the confusion of appearances as they normally strike us. In the Poussin the leaves are as defined as those of a book. Yet this clarity is not a question of fussy accuracy. On the contrary Poussin painted broadly and simply – the surface of his painted flesh like that of water running shallowly and imperceptibly over a perfectly smooth pebble. His clarity is the result of order. Nothing in his figure paintings (his late landscapes are different) has been snatched from chaos or temporarily rescued from mystery. The wind blows in the right direction to furl the striding nymph's golden dress so that it becomes a precise extension and variation on her own movement. The reeds break, and point like arrows to the focal centre of the scene. The sitting nymph's foot forms a perfect ten-toed fan with the foot of the child.

Yet why, then, is the picture not completely artificial? For two reasons. First, because Poussin's intensely sensuous vision of the human body forced him – as true sensuousness, as opposed to vicarious eroticism, must always do – to recognize the nature of physical human energy. His figures move with the same inevitability as water finds its own level, and consequently they transcend their rhetorical gestures. A man, after all, lifts his arm to stop a bus in the same way as he might wave to greet the spirit of a poet on Parnassus. And in this painting the kneeling foster-father could be wringing out a wet towel just as well as holding the head of the goat between his legs. Secondly, because the scene, given its arrangement, is still *visually* true. For example, the deep velvet blue of the sitting nymph's robe, the pale aquamarine dress of the nymph on the rocks and then the sudden porcelain blue of the sky behind the hills

– these blues, in a cereal-coloured landscape, clash, welcome, correspond and set up distances between themselves just as blues can do on Boat Race day.

And so we think: this is not another world, nor is it even a stage fantasy. Here the aspect of a shoulder or a breast is like the voice of an actress delivering Racine's words: we have seen and heard them in different situations. This is simply the world ordered beyond any previous imagining.

Which brings us to the crux of the matter and the second discovery. Poussin's sense of order added up to something more than an impeccable sense of composition – as we now use the term. Compare the studio works or the copies at Dulwich with the artist's own works. On the canvas they are sometimes just as well arranged or composed. But only on the canvas. The shapes and colours and lines are ordered. But not the scene itself. In front of a Poussin one feels that he brought order to the slice of life he was painting before he even picked up a brush: that he posed his whole subject, as he might have posed a single model: that his power to organize didn't just derive from the act of painting, but from his whole attitude to life itself. It is by this that we are elated. A Poussin is not simply evidence that a master can control his medium: it is evidence that a man has believed that man can control his fate. We have the same sense of elation in front of Renaissance artists like Piero, Mantegna, and to some extent Raphael, who was Poussin's own star. But because Poussin was working a century later and painting had become very much more complex, Poussin's expression of order was wider in scope. In front of a Piero we see, as it were, the blueprint of an ordered world; in

front of a Poussin we see velvet, metal, flesh and the time of day all far more tangibly under control.

And now how can one explain this historically? I suspect the full explanation will upset a good many apple-carts, for clearly Poussin was simultaneously both a very reactionary and a very revolutionary artist. He was reactionary because for his subjects and for his examples – classical sculpture and the works of the mid-Renaissance – he looked backwards, and also because probably his sense of order derived from, and was sustained by, the absolutism of the France of Louis XIII and XIV. One has only to compare him to his contemporaries, such as Rembrandt, Velasquez or Galileo, to see how far he stood apart from the new subjects, the new problems and the progressive possibilities of his time.

He was a revolutionary artist, not only because his work was supremely rational – and consequently was to inspire the revolutionary classicism of David – but even more profoundly, because his determination to demonstrate the possibility of man controlling his fate and environment made his art the solitary link, in this respect, between the two periods when such a control could generally be believed in: the Renaissance and our own century. Between Poussin and Cézanne there were many works of genius, but none of them suggest an order imposed upon nature before the act of painting. Which is why Cézanne knew he had to go back to Poussin in order to continue from where Poussin had stopped.

Poussin's system of order was static – however much energy his figures may imply. Look at *The Triumph of David*. If as a result of the implied movement of the trium-

phal procession, we reckon with new consequences and changed circumstances, the whole unity of the picture falls to bits. What happens when the procession moves on and the head of Goliath no longer coincides with the robes of the spectator behind, and the folds of those robes no longer echo the victorious arm of David? For this reason Poussin could not deal with the constantly moving dynamic forces of nature, as expressed in full, open landscapes; he then had to let in mystery, the unknowable. His struggle, with inadequate means, to avoid doing this is very moving. In *A Roman Road* he tries desperately to keep everything under control: he emphasizes the straight edge of the man-made road, he makes as much as he can of the calculated angles of the church roof, he disposes the small figures in their telling, clear poses, but the evening light making shadow chase shadow, the sun going down behind the hills, the awaited night – these are too much for him. For Poussin there was chaos beyond the town walls, beyond the circle of learning – as there was bound to be until it was realized that human consciousness had as material a basis as nature itself.

And it was from this point that Cézanne continued. Cézanne's incredible struggle was to find some system of order which could embrace the whole of nature and its constant changes. Against his wishes this struggle forced him to abandon the order of the static viewpoint, to admit that human consciousness was subject to the same dialectical laws as nature. And the Cubists continued from where he stopped, rejecting the Renaissance because they were aiming at the same end with quite different means. Even today the process is incomplete, the solution only partial.

But for those who will take the next step forward, Poussin, straddling the two periods in our culture when men sought order in life before they sought it in art, will remain an inspirer.

WATTEAU AS THE PAINTER OF HIS TIME

Historical generalizations – and particularly Marxist ones – can dangerously over-simplify. Yet unless one takes into account the fact that the eighteenth century ended with the French Revolution, it is impossible to understand how Watteau was so incomparably greater than all his followers.

The eighteenth century in France saw the complete transformation of power from the aristocracy to the middle class. The struggle and contradictions behind this transformation were reflected in the art of the period – but reflected in a highly complicated way. By the beginning of the century, following the death of Louis XIV, the doctrine of absolute monarchism was dead and with it declined the solemn, monumental, impersonal classicism of Poussin, Le Brun, Racine. There followed the transitional rococo art of Watteau, Fragonard, Boucher, whose public was the aristocracy now freed – fatally – from royal obligations and restraint, and the affected *élite* of the rising middle class. It was a transitional art because it preserved much of the artificiality of the previous classicism but introduced more movement (Watteau was greatly influenced by Rubens) and substituted casual Dalliance and Elegance for imperial Power and Dignity. In reaction to its hedonism, but continuing its tendency towards movement, characterization and informality, there arose the middle-class art of such painters as Chardin and Greuze: an art based on the virtues of domesticity, industry and personal responsibility. Finally under David there was the return to Classicism as the only sufficiently heroic style for the revolution itself.

Lessons from the past

But this classicism was very different from that of the seventeenth century: it was far more concerned psychologically with the individual and contained much of the realistic observation of the preceding genre-painters.

Such is the bare outline of development. How did this affect Watteau? No historical analysis explains genius; it can only help to explain the way genius develops. If one compares Watteau's fêtes-galantes with similar works by Pater, Fragonard or Robert, their greater depth of meaning and observation becomes immediately obvious. The hands of a figure in a Fragonard are merely elegant gestures terminating the movement of an arm; in a Watteau the hands of each figure, however small, have their own energy as they restlessly finger the strings of a guitar or bodice. Faces in the work of the other painters are automatic, like the made-up faces of a chorus; in a Watteau, however silken the dalliance and finery, beady eyes look out from faces expressing all the desperation of an unrealized boredom with pleasure – an echo almost of voices in Chekhov. Watteau's followers painted the stage of 'manners' as seen from the auditorium; he himself painted the performance from the wings whence one can occasionally see a performer querying his role. In his fragment of a *Girl's Head* one is suddenly made to realize the disturbing (or encouraging) fact that no make-up can ever disguise the expression of the eyes. Or compare Watteau's nudes with those of Robert or Boucher. For Boucher nudity was a commercial aphrodisiac; for Watteau it was a moment – evanescent as everything else – of intimacy.

And so one comes to the now accepted view of Watteau's art. 'The content of Watteau's work, if we may dare state

it in a word, is mortality – that fatal sense of life's transience about which his every picture whispers but never speaks openly,' as Mr Gordon Washburn has put it. Watteau's own temperament and his suffering from tuberculosis obviously contributed to his vision. But what made his expression of such an attitude to life larger than his personal feelings and bigger than the subjects he represented, was that he expressed so surely the reality of his time. He revealed in feeling the true transitional nature of the style he worked in. He remained (and was born) outside the social order he painted, but the ambivalence of the mood of his work was a perfect expression of the nature and destiny of that order. It was to be said later, 'Under Louis XIV no one dared open his mouth, under Louis XV everyone whispered, now everyone speaks out loud and in a perfectly free-and-easy way.' The whispering in Watteau's paintings (which both quotations refer to) is partly a nostalgia for a past order, partly a premonition of the instability of the present; partly an unknown hope for the future. The courtiers assemble for the embarkation for Cythera but the poignancy of the occasion is due to the implication that when they get there it will not be the legendary place they expect – the guillotines will be falling. The paradox is that whenever an artist achieves such a true expression of his time as Watteau did, he transcends it and comments on a permanent aspect of life itself: in Watteau's case on the brevity of it. The difference between Watteau and his followers (Fragonard's landscapes are in a separate category) is that they were unable to see beyond the consoling pretence of the charades they painted – and incidentally were therefore very much more popular with their public.

Lessons from the past

THE POT-BOILER

George Morland's personal story was a tragic one. Following the fashionable lead of his time (epitomized by the Prince of Wales) he dissipated his talents and his life (1763–1804). Debts forced up his output – during the last eight years of his life he produced at least 100 canvases a year; whilst drink and false stimulation of every sort made his work even more automatic and repetitive than it might otherwise have been. Occasionally, as in the small innocent painting of a *Cat Drinking Milk* or the *Gypsy Encampment* landscape, he relaxed enough to study and feel something about his subject. But on 990 out of 1,000 canvases (no exaggeration) he worked like a hack scene painter rushed before an opening night.

Morland was brought up by his father, a restorer and portrait painter, on Stubbs, Gainsborough and the Dutch landscapists. His early pictures, however, were mostly drawing-room anecdotes or *galanteries* – *The Mutual Confidence* of two ladies after tea (Jane Austen was twelve years younger than Morland), *The Fortune Teller* at the card table, *The Soldier's Departure* and, of course, *The Soldier's Return*. Many of these were engraved and achieved great popularity, particularly those that dealt with children and in which sweetness could be mistaken for sensibility. In about 1790 Morland changed his genre and began to concentrate on his more famous rustic scenes, set, as it were, Beneath the Spreading Chestnut Tree. These appealed to the current sentimentalization of Rousseau's doctrines, but were in fact as artificial and dressed up as his earlier pic-

tures. Gillray, who continued the spirit of Hogarth and whose allegiance was to the sturdier more down-to-earth aspect of the middle-class outlook, satirized both types of Morland: the dandified cissyness of the *galanteries* and the idea behind the farmyard scenes that Nature was all bacon and ale. Indeed, if one compares Hogarth's series of *Industry* and *Idleness* with Morland's *The Comforts of Industry* and *The Miseries of Idleness*, one sees the precise hypocrisy underlying Morland's appeal. The contrast between Hogarth's apprentices is total. Even the rhythm of the composition of the pictures is affected. But the difference between the families in Morland's two paintings is only that of a change of clothes and a wash and brush up.

Morland's sentimentality is, of course, proverbial, but it is interesting to see the superficiality of his ideas so completely reflected in his forms – in the way he actually painted and drew. The *form* of every twig, piece of thatch and forelock he limned in, betrays, in exactly the same way as his attitude to the *content* of his work, an attempt to describe an effect instead of a cause.

He slipped a formula like a harness over everything he drew. All his branches make the same gesticulations, all his straw is untidy in the same methodical way. His figures are conjured up by buckles, tatters, highlights – they deceive only as scarecrows deceive birds. And because of this, because he was only concerned with the tension of pure illusion – the tension between a few minimum effects and the eye of the spectator – he was incapable of composing. He knew how to balance a picture in an automatic way, but the groups of his objects and people never cohere. Because there is no tension between them, each remains

separate. One could take one figure from one painting and swap it with a roughly similar shaped figure from another, without disturbing either picture at all. Compare Morland with Wilkie. The difference is extraordinary. Although in some ways Wilkie was a much looser painter, every figure, brushmark and colour is interlocked: the painting grows, encompassing one in its own life, which in turn derives from the life of its subject. Before Morland's one is only aware of standing in front of them, as one is suddenly made aware of being in the theatre when the canvas scenery billows.

Permanent Red

Goya's genius as a graphic artist was that of a commentator. I do not mean that his work was straightforward reportage, far from it; but that he was much more interested in events than states of mind. Each work appears unique not on account of its style but on account of the incident upon which it comments. At the same time, these incidents lead from one to another so that their effect is culminative – almost like that of film shots.

Indeed, another way of describing Goya's vision would be to say that it was essentially theatrical. Not in the derogatory sense of the word, but because he was constantly concerned with the way action might be used to epitomize a character or a situation. The way he composed was theatrical. His works always imply an encounter. His figures are not gathered round a natural centre so much as assembled from the wings. And the impact of his work is also dramatic. One doesn't analyse the processes of vision that lie behind an etching by Goya; one submits to its climax.

Goya's method of drawing remains an enigma. It is almost impossible to say *how* he drew: where he began a drawing, what method he had of analysing form, what system he worked out for using tone. His work offers no clues to answer these questions because he was only interested in *what* he drew. His gifts, technical and imaginative, were prodigious. His control of a brush is comparable to Hokusai's. His power of visualizing his subject was so precise that often scarcely a line is altered between pre-

paratory sketch and finished plate. Every drawing he made is undeniably stamped with his personality. But despite all this, Goya's drawings are in a sense as impersonal, as automatic, as lacking in temperament as footprints – the whole interest of which lies not in the prints themselves but in what they reveal of the incident that caused them.

What was the nature of Goya's commentary? For despite the variety of the incidents portrayed, there is a constant underlying theme. His theme was the consequences of Man's neglect – sometimes mounting to hysterical hatred – of his most precious faculty, Reason. But Reason in the eighteenth-century materialistic sense: Reason as a discipline yielding Pleasure derived from the Senses. In Goya's work the flesh is a battleground between ignorance, uncontrolled passion, superstition on the one hand and dignity, grace and pleasure on the other. The unique power of his work is due to the fact that he was so *sensuously* involved in the terror and horror of the betrayal of Reason.

In all Goya's works – except perhaps the very earliest – there is a strong sensual and sexual ambivalence. His exposure of physical corruption in his Royal portraits is well known. But the implication of corruption is equally there in his portrait of Dona Isabel. His Maja undressed, beautiful as she is, is *terrifyingly* naked. One admires the delicacy of the flowers embroidered on the stocking of a pretty courtesan in one drawing, and then suddenly, immediately, one foresees in the next the mummer-headed monster that, as a result of the passion aroused by her delicacy, she will bear as a son. A monk undresses in a brothel and Goya draws him, hating him, not in any way because he himself is a puritan, but because he senses that the same impulses

that are behind this incident will lead in the Disasters of War to soldiers castrating a peasant and raping his wife. The huge brutal heads he put on hunchback bodies, the animals he dressed up in official robes of office, the way he gave to the cross-hatched tone on a human body the filthy implication of fur, the rage with which he drew witches – all these were protests against the abuse of human possibilities. And what makes Goya's protests so desperately relevant for us, after Buchenwald and Hiroshima, is that he knew that when corruption goes far enough, when the human possibilities are denied with sufficient ruthlessness, both ravager and victim are made bestial.

Then there is the argument about whether Goya was an objective or subjective artist; whether he was haunted by his own imaginings, or by what he saw of the decadence of the Spanish Court, the ruthlessness of the Inquisition and the horror of the Peninsular War. In fact, this argument is falsely posed. Obviously Goya sometimes used his own conflicts and fears as the starting point for his work, but he did so because he consciously saw himself as being typical of his time. The intention of his work was highly objective and social. His theme was what man was capable of doing to man. Most of his subjects involve action between figures. But even when the figures are single – a girl in prison, an habitual lecher, a beggar who was once 'somebody' – the implication, often actually stated in the title, is 'Look what has been done to them.'

I know that certain other modern writers take a different view. Malraux, for instance, says that Goya's is 'the age-old religious accent of useless suffering rediscovered, perhaps for the first time, by a man who believed himself to be

indifferent to God'. Then he goes on to say that Goya paints 'the absurdity of being human' and is 'the greatest interpreter of anguish the West has ever known'. The trouble with this view, based on hindsight, is that it induces a feeling of subjection much stronger than that in Goya's own work: only one more shiver is needed to turn it into a feeling of meaningless defeat. If a prophet of disaster is proved right by later events (and Goya was not only recording the Peninsular War, he was also prophesying) then that prophecy does not increase the disaster; to a very slight extent it lessens it, for it demonstrates that man can foresee consequences, which, after all, is the first step towards controlling causes.

The despair of an artist is often misunderstood. It is never total. It excepts his own work. In his own work, however low his opinion of it may be, there is the hope of reprieve. If there were not, he could never summon up the abnormal energy and concentration needed to create it. And an artist's work constitutes his relationship with his fellow men. Thus for the spectator the despair expressed by a work can be deceiving. The spectator should always allow his comprehension of that despair to be qualified by *his* relationship with his fellow men: just as the artist does implicitly by the very act of creation. Malraux, in my opinion – and in this he is typical of a large number of disillusioned intellectuals – does not allow this qualification to take place; or if he does, his attitude to his fellow men is so hopeless that the weight of the despair is in no way lifted.

One of the most interesting confirmations that Goya's work was outward-facing and objective is his use of light.

In his works it is not, as with all those who romantically frighten themselves, the dark that holds horror and terror. It is the light that discloses them. Goya lived and observed through something near enough to total war to know that night is security and that it is the dawn that one fears. The light in his work is merciless for the simple reason that it shows up cruelty. Some of his drawings of the carnage of the Disasters are like film shots of a flare-lit target after a bombing operation; the light floods the gaps in the same way.

Finally and in view of all this one tries to assess Goya. There are artists such as Leonardo or even Delacroix who are more analytically interesting than Goya. Rembrandt was more profoundly compassionate in his understanding. But no artist has ever achieved greater honesty than Goya: honesty in the full sense of the word meaning facing the facts *and* preserving one's ideals. With the most patient craft Goya could etch the appearance of the dead and the tortured, but underneath the print he scrawled impatiently, desperately, angrily, 'Why?' 'Bitter to be present', 'This is why you have been born', 'What more can be done?' 'This is worse'. The inestimable importance of Goya for us now is that his honesty compelled him to face and to judge the issues that still face us.

Lessons from the past

THE DILEMMA OF THE ROMANTICS

The term Romanticism has recently been taken to cover almost all the art produced in Europe between about 1770 and 1860. Ingres and Gainsborough, David and Turner, Pushkin and Stendhal. Thus the pitched battles of the last century between Romanticism and Classicism are not taken at their face value, but rather it is suggested that the differences between the two schools were less important than what they both had in common with the rest of the art of their time.

What was this common element? To take a century of violent agitation and revolt and then to try to define the general, overall nature of its art, is to deny the very character of such a period. The significance of the outcome of any revolution can only be understood in relation to the specific circumstances pertaining. There is nothing less revolutionary than generalizing about revolution. However, a stupid question usually gets stupid answers. Some try to define Romantic art by its subject matter. But then Piero di Cosimo is a Romantic artist along with George Morland! Others suggest that Romanticism is an irrational force present in all art, but that sometimes it predominates more than at other times over the opposite force of order and reason. Yet this would make a great deal of Gothic art romantic! Another observes that it must all have had something to do with the English weather.

No, if one must answer the question – and as I've said, no answer is going to get us all that far – one must do so historically. The period in question falls between the growing

points of two revolutions, the French and the Russian. Rousseau published *Le Contrat Social* in 1762. Marx published *Capital* in 1867. No two other single facts could reveal more. Romanticism was a revolutionary movement that rallied round a promise which was bound to be broken: the promise of the success of revolutions deriving their philosophy from the concept of the natural man. Romanticism represented and acted out the full predicament of those who created the goddess of Liberty, put a flag in her hands and followed her only to find that she led them into an ambush: the ambush of reality. It is this predicament which explains the two faces of Romanticism: its exploratory adventurousness and its morbid self-indulgence. For pure romantics the two most unromantic things in the world were firstly to accept life as it was, and secondly to succeed in changing it.

In the visual arts the two faces reveal themselves in a sense of new dimensions on the one hand, and in an oppressive claustrophobia on the other. They are Constable's clouds formed by land and water we can't see, and there is the typical romantic painting of a man being buried alive in his coffin. There is Géricault looking calmly and openly at the inmates of an asylum, and there are the German Romantic painters in the Mediterranean painting the hills and sky such a legendary blue that the whole scene looks as though it could be smashed like a saucer. There is Stubbs scientifically comparing animals and looking into the eyes of a tiger, and there is James Ward reducing Gordale Scar to a rock of ages just cleft for him. There is a new awareness of the size and power of the forces in the world – an awareness which invested the word *Nature* with a com-

pletely new meaning, and there is the breathlessness of the new superstitions that protected men from the enormity of what they were discovering: above all the superstition that a feeling in the heart was somehow comparable with a storm in the sky.

Naturally the focal centres of Romantic art varied a great deal according to time and place. In England the provocation was the Industrial Revolution and the new light (literal and metaphorical) that it threw on landscape; in France the predominant stimulus was the new mode of military heroism established by Napoleon; in Germany it was the mounting compulsion to establish a national identity. Naturally, too, the political predicament I've described often presented itself in indirect forms. More Romantic artists were directly influenced by the literary cult of the past when life was thought to have been 'simpler' and more 'natural', than they were by, say, Chartism. Newtonian science was also relevant to Romanticism. The Romantics accepted the way science had freed thought from religion, but at the same time were intuitively in protest against its closed mechanistic system, the inhumanity of which seemed to be demonstrated in practice by the horrors of the economic system. The complexities of the situation are immense. Certain artists of the time, precisely because they were not affected by the Romantic predicament, should not be classed as Romantics even though they borrowed from the Romantic vocabulary: *e.g.* Goya and Daumier.

Yet, despite the complexities, this historical definition is the only one that will make any general sense at all. It is confirmed by the fact that after 1860 when the predica-

ment was no longer real because the knowledge and experience with which to overcome it were available, Romanticism degenerated into effete aestheticism. And it is confirmed most strikingly by the work which represents Romanticism at its height: Delacroix's *Massacre at Chios*.

The sub-title of the picture is *A Greek Family Awaiting Death or Slavery*. It is an acknowledged masterpiece and contains brilliant passages of painting. Its political gesture was important and also undoubtedly sincere. But it remains a gesture. It has nothing to do with any true imaginative understanding of either death or slavery. It is a voluptuous charade. The woman tied to the horse is a languorous sex-offering, the rope round her arm like an exotic snake playing with her. The couple in the centre might be lying in a harem. Indeed all the figures (with the possible exception of the old woman) are exotic. They belong to art dreams and literary legends, and have only been placed in an actual context for the sake of being 'ennobled' further by also belonging to an historical tragedy.

Delacroix records how he talked to a traveller just back from Greece and says that on one occasion this man 'was so much impressed by the head of a Turk who appeared on the battlements that he prevented a soldier from shooting at him.' Elsewhere Delacroix raves about a painting by Gros and says, 'You can see the flash of the sabre as it plunges into the enemy's throats.' Such was the romantic view of war: you could stop or start it like a film. It was a sincere view, but it was a compromisingly privileged view. And between the privilege and the reality lay the predicament.

Lessons from the past

MILLET AND LABOUR

Millet's holy humble peasants have been used to illustrate many moral lessons and have comforted many uneasy consciences: the consciences of those who have borne everything 'with fortitude', but who suspect themselves of perhaps having accepted too much too passively: also, the consciences of those who, living off the labour of others, have nevertheless always believed that in an indescribable sort of way (and God help those who describe it too explicitly) the labourer has a nobility which they themselves lack. And, above all, Millet's pictures have been quoted to persuade the confined to count the blessings in their cells; they have been used as a kind of pictorial label round the great clerical bottle of Bromide prescribed to quieten every social fever and irritation. This is a more important part of the history of Millet's art than the fact that highbrow fashion has ignored him for the last thirty or forty years. Otherwise what is important is that such artists as Degas, Monet, Van Gogh, Sickert, all accepted as a matter of course that he was a great draughtsman. In fact, Michelangelo, Poussin, Fragonard, Daumier, Degas, can all be cited in discussing his work – though it is only necessary to do so in order to convince the 'art-loving' public, misled by its textbooks, that Millet was not just a kind of John the Baptist forerunner of the Pre-Raphaelites or of Watts. But when that has been said, it is the moral issue which is *the* issue that Millet raises.

Millet was a moralist in the only way that a great artist can be: by the power of his identification with his subjects.

He chose to paint peasants because he was one, and be-cause – under a somewhat similar influence to the unpoli-tical realists today – he instinctively hated the false elegance of the beau monde. His genius was the result of the fact that, choosing to paint physical labour, he had the passion-ate, highly sensuous and sexual temperament that could lead him to intense physical identification. Sir Kenneth Clark makes much of the point that at the age of thirty-five he gave up painting nudes which were – but only in the mythology they employed – a little like eighteenth-century boudoir art. Yet there was no inhibited puritanism behind this decision. Millet objected to Boucher because 'he did not paint nude women, but only little creatures undressed'.

As for the nature of Millet's power of identification, this is clearly revealed in one of his remarks about a drawing by Michelangelo.

When I saw that drawing of his in which he depicts a man in a fainting fit – I felt like the subject of it, as though I were racked with pain. I suffered with the body, with the limbs, that I saw suffer.

In the same way he strode forward with *The Sower*, felt the weight of the hand on a lap even when it was obscured in shadow (see his etching of a *Mother Feeding her Child*), embraced with the harvesters the trusses of hay, straight-ened his back with the hoers, clenched his leg to steady the log with the wood-cutters, leant his weight against the tree trunk with the shepherdess, sprawled at midday on the ground with the exhausted. This was the extent of his moral teaching. When he was accused of being a socialist, he denied it – although he continued to work in the same way

and suffer the same accusation – because socialism seemed to him to have nothing to do with the truth he had experienced and expressed: the truth of the peasant driven by the seasons: the truth so dominating that it made it absolutely impossible for him to conceive of any other life for a peasant.

It is fatal for an artist's moral sense to be in advance of his experience of reality. (Hogarth's wasn't; Greuze's was.) Millet, without a trace of sentimentality, told the truth as he knew it: the passive acceptance of the couple in *The Angelus* was a small part of the truth. And the sentimentality and false morality afterwards foisted upon this picture will prove – perhaps already has proved – to be temporary. In the history of nineteenth- and twentieth-century art the same story is repeated again and again. The artist, isolated, knows that his maximum moral responsibility is to struggle to tell the truth; his struggle is on the near side, not the far, of drawing moral conclusions. The public, or certain sections of it, then draw moral conclusions to disguise the truth: the artist's work is called immoral – Balzac, Zola: or is requisitioned for false preaching – Millet, Dostoevsky: or, if neither of these subterfuges work, it is dismissed as being naive – Shelley, Brecht.

THE VICTORIAN CONSCIENCE

Hope sits like a waif on the world. The picture was as popular as *Love Locked Out* and *Bubbles*. The transience of childhood, the impossibility of love, the elusiveness of hope – these were the themes that sustained the Victorians in their confidence and comfort. The nature of their guilt may have been complex but the resulting ambivalence of their faith is very clear in all their painting – clearer than in their literature. And Watts epitomized Victorian painting.

In almost everything he did there is a threatening gulf between his ideals and the subjects in which he chose to embody them. Nothing is taken for what it is. The wish was Victorian father to the thought. Tennyson, who in some ways resembled Watts, was painted as though he were a blind man: his eyes unseeing in order that his inner vision might be preserved. Ellen Terry (whom Watts married when she was sixteen) is a scentless flower.

It is impossible to pin down the exact cause of Watts's painful ambivalence and anxiety. He had an uneasy social conscience and sometimes made direct social protests in his work, but also his fears were highly personal. Obsessed by death, he painted several pictures of Cain. In his remarks about these, both aspects of his conflict come out:

> Cain is in the grasping of riches to the hurt of others, or in indifference to others; in the building of houses unfit for dwelling in; in the polluting of streams without regret.

But also, desperately identifying himself with Cain, he wrote:

Not only are his fellow men unconscious of his presence, but all inanimate nature has cast him out: no bird or living creature acknowledges his being.

These conflicts, always partially suppressed, fatally affected his talents as an artist. He was unable to draw. What he wished his subject to stand for, came between him and its form. He thought that the aim of art 'should be to give the impression of some great truth of nature, something so far too great for expression that finally it must remain indefinite. The infinite looming behind the finite.' It loomed so large that the pucker of the brow destroyed the form of the skull – or prevented him ever seeing it: the anxiety of the eyes dissolved the eye sockets. Occasionally, as in his portrait of Cardinal Manning, the intensity of feeling is tremendous. But one only wonders: Was it really possible to see a man like that? Never: Was he really like that?

Some of his small drawings are comparatively successful, but then any reasonably talented artist produces a few good sketch-book studies during his lifetime. Nor is this harsh judgment a question of changing visual taste – one has only to compare Watts with Millet. One might argue that Watts's lack of proper training explained the weakness of his drawing, but that he compensated for this by his mastery of Titianesque colour. But his colour suffers from the same fault. Ruskin wrote to him saying, 'You depend too much on blending, and too little on handling.' To handle colour is, as it were, to grasp it. Watts could not have committed himself to that extent. His colour is strong but elusive because it never *belongs* to the forms. In his early eighteenth-century-like portraits, the colour is applied like

rouge to the pink cheeks. In his later allegorical works the colour is like thick stained glass through which one sees darkly the subject on the other side. It is the same with his sculpture. He could never accept the subject as an organic whole. In his bust of *Clytie*, the muscles were modelled from a man, the face from a woman. And it is this separation of the parts which causes, amongst other things, the nipples to appear so incongruously blatant – one wonders what Gladstone said and noticed when Watts asked his opinion.

As in all Victorian art, it is the sexual element in Watts's work which reveals his conflicts most clearly. Swinburne talked of the 'amorous chastity' of one of his paintings: a concise if unintentional way of summing up their sensual contradiction. The folds of the draperies round Watts's figures are incredibly tortured and overworked in their complexity because they were believed to hide so much – far more than they in fact did. *Dawn*'s cloak is about to slip off as she watches the day break above the mountains. Yet when it does, it will not reveal her body, but the never-to-be-looked-at sun which consumes everything.

Watts worked hard, lived in luxury and was acclaimed and petted by society, but when he looked up at the reflection of a night light on the ceiling, he got his first idea for his painting of the origin of the cosmos *The Sower of the Systems*. When he described how he had worked on this picture, he compared himself to a child, asked to draw God and who 'putting his paper on a soft surface, struck his pencil through the centre, making a great void.' He was a typical Victorian but he was nearer to our revolution than we tend to think. *Watchman, What of the Night?*

he asked. It was Rimbaud who was to reply to that. As an artist Watts failed, but his failure was more significant than that of many contemporaries today who run away from what they believe is the void even faster, only in a different direction.

Permanent Red

Because Courbet was a declared and incorruptible Socialist (he was of course imprisoned for the part he played in the Commune and at the end of his life was driven into exile in Switzerland), reactionary critics have pretended that his politics were nothing to do with his art – they couldn't deny his art itself if only because of his important influence on later artists such as Manet and Cézanne; progressive critics, on the other hand, have tended to assume that his art is great as an automatic result of his political loyalty. So it is pertinent to ask exactly how his socialism was implied in his paintings, how his attitude to life was reflected in the innovations of his art.

First, though, it is necessary to clean off some of the mud that has stuck. Because Courbet was uncompromising in his convictions, because his work and his way of life 'vulgarly' proved that art was as relevant to the back-parlour, the workshop, the cell, as to the drawing-room, because his paintings never offered the slightest possibility of escape from the world as it was, he was officially rejected in his lifetime and has since been only grudgingly admitted. He has been accused of being bombastic. Look at his self-portrait in prison. He sits by the window quietly smoking his pipe, the invitation of the sunlight in the courtyard outside the only comment on his confinement. Or look at his copy of the Rembrandt self-portrait. He had the humility to impose that discipline on himself at the age of fifty. He has been accused of coarseness. Look at a Normandy seascape, in which the receding air between the empty sea

196

and the low clouds holds firmly but with an extraordinary finesse all the mystery implied by the apparent fact and the actual illusion of an horizon. He has been charged with sentimentality. Look at his painting of the great hooked trout; its truth to the essential facts forces one to feel the weight of the fish, the power with which, struggling, his tail would slap the rocks, the cunning necessary to play him, the deliberation necessary to gaff him – he would be too large to net. Occasionally, of course, such criticisms are fair, yet no artist only paints masterpieces, and the work, say, of Constable (whom Courbet in his independent contribution to landscape painting somewhat resembled), Corot or Delacroix is just as unequal, but is far less frequently singled out for prejudiced attack.

But to return to the main problem: Courbet believed in the independence of the artist - he was the first painter to hold a one-man show. Yet to him this meant independence from art for art's sake, from the prevailing Romantic view that the artist or his work were more important than the existence of the subject painted, and from the opposing Classic view that the inspiration of all art was absolute and timeless. He realized that the artist's independence could only be productive if it meant his freedom to identify himself with his living subject, to feel that *he* belonged to *it*, never vice versa. For the painter as such that is the meaning of Materialism. Courbet expressed it in words – this indestructible relationship between human aspiration and actual fact – when he wrote, '*Savoir pour pouvoir – telle fut ma pensée.*' But Courbet's acknowledgment, with all the force of his imagination, of the actuality of the objects he painted, never deteriorated into naturalism: a thoughtless super-

ficial goggling at appearances – a tripper's view of a beauty spot, for instance. One does not just feel that every scene he painted *looked* like that but that it was *known* like that. His country landscapes were revolutionary in so far as they presented real places without suggesting any romantic antithesis with the city, but within them – not imposed upon them – one can also discover a sense of potential Arcadia: a local recognition that for playing children and courting couples such ordinary scenes might gather familiar magic. A magnificent nude in front of a window and landscape is an uncompromising portrayal of a woman undressed – subject to many of the same laws as the trout: but, at the same time, the picture evokes the shock of the unexpected loneliness of nudity: the personal shock that inspires lovers, expressed in another way in Giorgione's *Tempest*. His portraits (the masterpieces of Jules Vallès, Van Wisselingh, The Hunter) are particular people; one can imagine how they will alter; one can imagine their clothes worn, ill-fitting, by somebody else; yet they share a common dignity because all are seen with the knowledge of the same man's affection. The light plays on them kindly because all light is welcome that reveals the form of one's friends.

A parallel principle applies to Courbet's drawing and grasp of structure. The basic form is always established first, all modulations and outcrops of texture are then seen as organic variations – just as eccentricities of character are seen by a friend, as opposed to a stranger, as part of the whole man.

To sum up in one sentence, one might say that Courbet's socialism was expressed in his work by its quality of uninhibited Fraternity.

Lessons from the past

RENOIR AND THE AFTERMATH

Renoir was the last great bourgeois artist. That is to say he was the last painter who was able to accept frankly bourgeois values of security, domesticity and leisure, and to make from these a confident art. The other Impressionists retreated from such concepts to emphasize the ephemeral and the casual. Bonnard, who in a different way tried to produce an art based on similar values to Renoir's, was forced to camouflage his intentions under cover of pure colour and pattern. Everything merges in nostalgic light. Bonnard is really a sort of urban Claude: a lost Arcadia lies beyond his french windows.

Look, for instance, at Renoir's *Woman seated at a Stove* or at his portrait of his small son Jean drawing at a table. For all their difference of temperament and technique, these two pictures evoke an atmosphere essentially the same as that evoked by a Chardin. And Chardin was perhaps the first great bourgeois artist, reacting in his time against what had become the nostalgic aimlessness of aristocratic art. Nor does one argue like this simply to prove a Marxist point. It leads one through a host of current illusions to a truer understanding of the art in question. Because Renoir painted and so obviously enjoyed the female nude, it is often said that he is the sensuous, sexual artist *par excellence*. But this is only a half truth. Certainly in every one of his pictures, even in his landscapes and flower-pieces, there is a voluptuous sexual awareness. But their mood is always – almost without exception – languid and drowsy. It is the aftermath of love that he paints – just as it is the dreamy

aftermath of a secure culture of material comfort and private property that he represents historically. Think, for example, of the concept of love and security in the films that his son Jean was to make. In one generation one can see how the climate had to change.

Renoir's greatness lies in the fact that he so completely and so honestly derived from actual subjects and images, symbols to correspond to his view of life: thus, the solid truth he discovered in them will remain meaningful long after the values imposed upon him by his class and time have come to seem one-sided. This brings us to an understanding of Renoir's development as an artist. One can see why he had to discard his early Courbet-like style which implied an austerity alien to his ideal of ease; how impressionism first offered him a way of communicating his sensuous delight but later began to destroy the substance of it; how Raphael, Cézanne and the draughtsman's discipline of Ingres showed him that only by the careful, patient study of Nature could he find the equilibrium, the peacefulness that could express his belief in sensuous comfort; how finally he was able to achieve – perhaps without realizing the significance of it himself – a true synthesis of the inevitable contradictions of his attitude – how in his later paintings he literally dissolved the outlines of the world in order to extend and make timeless the brief moment of physical contentment, of well-being without further desire.

GAUGUIN'S CRIME

Gauguin's life – poverty, disease, loneliness, disillusion, guilt – was wholly tragic. The legend of the stockbroker who chucked up his family and job, or that of the Genius sublimely above Responsibility, are inadequate both to the facts and to the suffering involved. Gauguin was a criminal. It may seem perverse to call a great artist that – and one must remember that his ruthlessness always extended to his own treatment of himself – but it is the only way, I think, of beginning to understand him.

Gauguin's self-portraits, after he left his family in Copenhagen and became an outcast, are very revealing, especially if one remembers the innocence of Van Gogh's. The large lumbering body, the big hooked nose, the dark eyes whose expression is defensive and gives nothing away, the whole face – like one carved forcefully but with a blunt knife out of crude wood – are seen bitterly, cynically, as though the image Gauguin saw in the mirror reminded him of how a convict might strike a prison visitor, or how a man might appear, brought up from a dark cell for interrogation.

His crime was his decision in 1883 to become a professional, dedicated painter. It amounted to a crime partly because of the social attitude forced upon the imaginative artist at that time, and partly because of Gauguin's own temperament. All the great works of the late nineteenth century were produced in the belief that the individual could only risk himself creatively *against* society. This by itself turned the artist into an outcast. One half of Gauguin's

character accepted this role so uncompromisingly that he was *treated* as a criminal: the other half, longing for acceptance and respect, made him *feel* a criminal. He instinctively understood both processes. 'A terrible epoch,' he wrote, 'is being prepared in Europe for the coming generation: the reign of gold. Everything is rotten, both men and the arts. You must understand that two natures dwell within me: the Indian and the Sensitive Man.' Although Gauguin claimed descent from the Peruvian Indians, the Indian also had a symbolic meaning for him: he was the Free Man, the Independent Hunter, the Pure Primitive of uncorrupted appetite. The sensitive man was the exact opposite: the man of Esteem, cultivated, articulate Taste, Affection and Family Feeling. The two combine, the independence of the Indian and the guilt of the Sensitive Man in such twisted agonized remarks as: 'Yes, I'm a great criminal all right. But what does it matter? Michelangelo also. And I'm not Michelangelo.'

All through his life until his attempted suicide six years before his death, this conflict continued. His letters from Panama, Brittany, Tahiti, the Marquesas, read like those of a man on the run, always planning to get over the border to security and comfort and a normal full life.

> You are without confidence in the future, but I have that confidence because I want to have it. Without that I should have long since thrown up the sponge. To hope is almost to live. I must live to do my duty to the end, and I can only do so by forcing my illusions, by creating hopes out of dreams. When day after day, I eat my dry bread with a glass of water, I make myself believe it is a beefsteak.

And at the end he wrote: 'You have known for a long

time what it is I wish to establish: the right to dare everything.' *Dare* not *Do*. In that difference of motive the conflict emerges again. One only talks of risking what one values.

It was not until after the death of his favourite daughter and his attempt at poisoning himself that Gauguin seems to have given up hope, or, more accurately, to have accepted his own terrible sentence on himself of deportation. His physical sufferings increased even further, but in his mind he achieved a certain reconciliation and calm.

Now, none of this would be worth pointing out and one could at least leave Gauguin his privacy, if it did not give us an important clue to understanding his art. Given the ideas of his time, Gauguin's painting was a very direct expression of his personality.

The Sensitive Man, robbed of security and sensibility, needed to dream. This might have led Gauguin to pure fantasy, symbolism, esoteric religious art – all of which he touched but never developed because the Indian in him required tangible trophies, required that 'the dream' should have weight and body to it. Hence his travels: to Brittany (where the dream had to be forced a little) and to the South Seas where dream and actuality were fused: the scene simultaneously exotic and stark.

The Sensitive Man inspired the mood and often the titles of the paintings: *Alone, Nevermore, Where do we Come From, What are We, Whither do We Go?* The Indian bound with contours as strong as leather the simple tangible forms. Neither was concerned with superficial illusions: both wanted to strip their subjects to what they thought was the heart of the matter: one to the essential mystery, the other to the instinctive body.

Consider the masterpiece *Nevermore*. Like all Gauguin's most original and mature works, it is, in one sense, clumsily painted. This clumsiness, however, is absolutely necessary to express the constant tension within the picture between the evocative and the real; between the hieratic gesture of a carved statue (or the stylized movement of a dancer) and the spontaneous pose of a Tahitian girl lying in wait on a couch: between flat decoration and solid structure: between allegorical and local colour. As in all Gauguin's later works, there is a marked distinction between the figure and its surroundings. The girl's body is modelled and physically convincing, the background is two-dimensional and schematic. As one thinks about this one suddenly realizes the explanation. The painting is the most accurate interpretation of what the girl herself might have felt as she lay there, intensely aware on the one hand of the reality of her own body, and, on the other hand, of the intangible comfort and threat of the dimensionless images projected around her from her own mind.

I believe that, sometimes very directly and sometimes less so, this duality of interpretation explains a great deal in Gauguin's greatest and most mysterious works. In his art he finally achieved his aim: to become a primitive and at the same time to remain finely articulate: to be simultaneously the Indian and the Sensitive Man. His work represents a single-handed attempt to build from primitive material an alternative civilization to the one he inherited. It is not altogether surprising that the latter considered the activity a criminal one.

The future

A culture is not the sum total of thousands of personal claims to 'understand' genius. In fact – if one is going to use a rough metaphor – works of art are like the stones of bridges which men have built and crossed together because they needed to travel in a particular direction. Yet now the bridges are being dismantled and the stones adapted into charming bird-baths for private gardens. What this reflects above all is our lack of energy in Europe.

I think of Diego Rivera. Is he a twentieth-century painter, or is he a Hercules? How much this man painted, how many square yards and themes and styles he covered during fifty years! He is surrounded by his work like an old man by a forest he planted when young. He himself in fact is difficult to find; his creations literally dwarf him. Now obviously there are all kinds of exterior explanations for this, and it would be absurd to compare Rivera with, say, Juan Gris and to conclude on the basis of their output (a theatre-backdrop compared to a postage stamp) that Gris was feeble and precious. What is far more significant is that Rivera's work – as also that of Orozco and Siqueiros – has, stylistically, a European basis. Rivera's masters were Giotto, Michelangelo, Cézanne and Picasso. So, after all, we sit back and congratulate ourselves? Far from it. What we might well do is to think again about the historical significance of modern European art. It is possible that its revolutionary discoveries – all of them now at least forty

years old – have led and will lead to far greater achievements outside Europe than within Europe.

Certainly this would seem to fit in with the nature of the artistic revolutions that occurred here round the turn of this century. Mostly these revolutions established new ways of seeing, new viewpoints and hence a new vocabulary and grammar of art. They represented in art the equivalent of the break with earlier bourgeois thought which was also occurring in science and politics. But they were, in the widest sense of the word, only technical revolutions. Naturally, they had an ideological basis, but the ideological conclusions to which they logically led were not followed up. They mostly remained exercises in a closed subject. Cubism, for example, seldom went beyond treating its subjects as still-lives. New methods were discovered, but not new themes, or new art forms. New possibilities were opened up, but then – as so often before in the history of bourgeois thought and science – social contradictions prevented them being realized. Many of the artists shrank back from the political implications of the demands made by the new art they had created. Others were daunted – understandably enough – by the barriers, created by centuries of bourgeois culture, between modern art and the class that alone could bring about a modern state: the working class. But there were – and are – other places in the world where these contradictions are less. And so it seems possible (and incidentally in accord with the effects of imperialism on the imperialist countries themselves) that just as capitalist Europe nurtured the idea of a socialism it has not yet been able to achieve itself, it has also created a modern art that it has not yet been able to develop.

The future

If this is so, we must turn many of our previous opinions inside out. No man is more central to modern European art than Picasso. And one of Picasso's major innovations was to 'import' African art and the art of other foreign cultures into European painting and sculpture. The significance of this is usually seen in terms of the effect it had on European art. Thus Herbert Read has compared such imported influences with 'injections of a drug: they act as a temporary stimulus and restore the body to health'. Yet probably the real importance of Picasso is that he has taught African and Asian and Latin American artists to see the connection between their own traditional art and the discoveries of the twentieth century.

A few useful definitions

Realism can only be defined within a given situation. Its methods and aims are always changing. For Masaccio the solidity of form was an essential of Realism. For the Impressionists the destruction of that solidity was an essential of Realism. The only thing shared by all Realists is the nature of their relationship to the art tradition they inherit. They are Realists in so far as they bring into art aspects of nature and life previously ignored or forbidden by the rule-makers. It is in this sense that Realists can be opposed to Formalists. Formalists are those who use the conventions of their medium (conventions that originally came into being for the purpose of translating aspects of life into art) to keep out or pass over new aspects. Thus, the Tachists use the technical conventions of Impressionism to keep out all observation of the relationship between actual objects. Thus, the more violent Action painters use the technical conventions of expressionism to keep out all social emotions. And, of course, what they keep out is what inspired those who created their conventions.

One should be able to define roughly, then, the present function of Realism by contrast. What do the rules of the new art forbid? The answer is staggering: any precise hopeful reference to the objective world. And so the Realist must look at the modern world, which has so unnerved the

Formalists, and come to terms with it. That is to say, he has got to answer the question – What is man? A question which, as Gramsci pointed out, really means: What can man become? Up to about 1920 artists could answer this question confidently enough without necessarily being socialists. Since then, if they are to reach a satisfactory answer, socialism has become increasingly necessary for them.

CONTENT AND SUBJECT MATTER

An artist's subject-matter is what he chooses to paint or sculpt – a woman, a battle, a flower. More often than not the subject can be summed up in the title of the work. *Content is what the artist discovers and emphasizes in his subject-matter.*

FORMALISM

All art is a formalization. Equally obviously much modern Western art has been reduced to meaninglessness as the result of an exclusive concern with form at the expense of content. The critical test is whether the formalization (which in some cases only consists of simplifications and in others of obvious distortion) emphasizes an aspect of the truth, or is simply made to improve the formal effect of the picture. No one objects to poetry differing from everyday speech, but one does object to a poet using words purely for the sake of their sound and rhythmic pattern. Even when this distinction has been made, however, the problem is not over. If an artist formalizes in order to emphasize

an aspect of the truth, one must inquire whether that aspect of the truth is sufficiently important and significant to justify the neglect or distortion of other aspects. In Picasso's *Guernica* extreme distortions were justified by the intensity of the protest and warning he made about the horrors of total war. Equally violent distortions made only to emphasize, say, the energy with which a man may wield a pick-axe, would probably be unjustified, because they would destroy too many other aspects of the truth, highly relevant to why he is wielding the pick-axe in the way he is. Thus, one arrives at an extremely important conclusion: *a style can never be criticized as such;* it can only be criticized in relation to what the artist is intending to communicate.

STATUS AND SUCCESS

The tragedy of art, and indeed of many other skills and trades, under the later stages of capitalism is that the status of the calling has been totally destroyed, and the standards of superficial success, either in terms of temporary reputation or money, have been put in its place. This has had a far-reaching effect on the artist.

An artist's status in society, when it has been established, is something which he feels behind him, supporting him, encouraging him. Success, with the meaning it has now acquired under capitalism, is something which may or may not happen quite arbitrarily to one or several of his finished works, considered merely as commodities. Thus, whether he seeks or despises success, whether his aim is to please or startle, the bourgeois artist's conscious or half-conscious concern with success takes the form of his having

to foresee, *whilst he is still working*, the likely effect of the finished work according to quite arbitrary criteria – arbitrary because in no way connected with the truth he may well be trying to communicate. The Bitch-Goddess prowls between him and his canvas, between intention and execution, inhibiting him, making him caricature himself or prompting unnecessary caution or unnecessary excess.

One could sum this up by saying that every sincere bourgeois artist in our society constantly faces *the possibility of being misunderstood;* and this is destructive of the imagination. Gorki wrote:

> True art arises when complete confidence is established between writer and reader . . . if he (the writer) speaks from his soul as if he were speaking to his best friend, he will be understood by the reader and accepted as a friend.

THE HERO AND THE IDOL

The hero in art is not of course just a man who is portrayed behaving bravely – or who ends up by marrying the heroine. The function of the hero in art is to inspire the reader or spectator to continue in the same spirit from where he, the hero, leaves off. He must release the spectator's potentiality, for potentiality is the historical force behind nobility. And to do this the hero must be typical of the characters and class who at that time only need to be made aware of their heroic potentiality in order to be able to make their society juster and nobler. Bourgeois culture is no longer capable of producing heroes. On the highbrow level it only produces characters who are embodied consolations for defeat, and on the lowbrow level it produces

idols – stars, TV 'personalities', pin-ups. The function of the idol is the exact opposite to that of the hero. The idol is self-sufficient: the hero never is. The idol is so superficially desirable, spectacular, witty, happy, that he or she merely supplies a context for fantasy and therefore, instead of inspiring, lulls. The idol is based on the *appearance* of perfection; but never on the striving towards it. In fact the idol does more than lull, because the spectator, identifying himself with the idol, and feeling that he shares or possesses its qualities, becomes complacent and self-satisfied.

EXTREMISM

It has often been pointed out that extremism is one of the characteristics of the modern movements in art – post-impressionism, cubism, expressionism. And critics have then followed up this observation by connecting extremism with a sense of desperation. This is surely generally true, but it seems to me that the nature of this desperation has changed fundamentally during the last eighty years.

The early 'modern masters' – Cézanne, Van Gogh, Gauguin, Picasso, Juan Gris, Braque, Matisse and others – were all, in their various ways, aware of the feebleness and corruption of bourgeois art and values and they all sensed that the twentieth century would produce a new type of man whom they wished to welcome even though they did not necessarily understand him. They knew that they lived on the eve of a revolution, and they considered themselves revolutionaries. But because they did not then understand the social and political nature of this revolution, they put all their revolutionary fervour into their art considered as

art. Because they did not see how to make a revolution in the streets, they made one on their canvases. (It is also interesting to note here that Lezer, who understood the true nature of the revolution taking place far better than any of his contemporaries, was the least extreme in spirit – the most calm.) The extremism of the early modern masters, in other words, was *affirmative* – and even though their work did little to help directly an actual social revolution, their fervour, desperate as it sometimes was, did lead them to make extremely important technical and aesthetic discoveries. The extremism of the so-called *avant-garde* now is of a quite different sort. Behind it is the desperation of despair. The *avant-garde* today are so terrified of what the world is becoming that they try to reduce it to the dimensions of their own unconscious, whilst boasting that these are the dimensions of the cosmos itself. The critical date was about 1920. Because after 1920 it was no longer possible to consider yourself a revolutionary without committing yourself politically.

A moral

In Holland in the seventeenth century a picture was painted. It was a portrait of a ship chandler's young wife. The artist was paid £50. The picture remained in the ship chandler's family for several generations. But there came a time when no one was any longer interested in their great-great-grandmother. The picture was then sold to a furniture dealer for the price of a new dress. The dealer sold it, along with a cabinet of inlaid wood, to an English gentleman. Twenty years later this gentleman's son moved from the family house in East Anglia to Nottingham, where he began to make a fortune from his coalfield. He had no time for paintings or inlaid cabinets. The picture lay forgotten in the attic of his house for nearly a century.

Not long ago it was given with a lot of other junk to a charity sale. An antique dealer saw it, recognized it as seventeenth century Dutch and bought it for £3.10.0. Quite soon afterwards an advertising executive, driving through York, stopped at the dealer's shop near the old city wall to see if he could buy a four-poster bed. He noticed the portrait and was instantly convinced that it was a Rembrandt. He bought it furtively for £40.

It was hung in his London flat in a place of honour. One of the firm's commercial artists confirmed that it was undoubtedly a Rembrandt – and so must be worth £40,000. The executive's friends and clients, who dropped in for a drink, were greatly impressed. The executive himself was

made very proud. He also argued that with this picture as security, he could take risks which would otherwise have frightened him. He took these unusual risks and made an unusual amount of money. He never asked an expert to authenticate the picture. This may be thought naive. But then who does bring in an outsider to verify a personal triumph? Besides, the picture served very well as a Rembrandt.

The executive had to go to the States for nine months. He let his flat to an old German friend. This man invited an art historian friend of his own to dinner. Clearly the painting was not a Rembrandt, said the art historian. When the executive returned from America, he was told the bad news. Another historian was called in and agreed with the first. The painting was taken down from the wall. The executive told his friends that he had sold it. In fact it was put into a cupboard.

A young painter went to see the executive to try to get work in the firm's studio. The executive took a liking to him and invited him to dinner. They drank quite a lot and the innocence of the young man reminded the older one of his own idealistic youth. Once he had dreamt of being a novelist. Waxing nostalgic and sentimental, he began to confess and tell of his disappointments in life. Amongst many other things he mentioned the Rembrandt. The young painter asked if he could see it. Perhaps it is not a Rembrandt, he said, but it is a marvellous painting. Then take it, the executive replied, it's yours. Don't try to get a job in one of our studios. You're the real McCoy, I can see that. Struggle on. And take this as a present. Thereupon he insisted on the young painter taking the picture away with

him under his arm that very night. If he had failed to discover a Rembrandt, he could at least discover how to be generous again – so he thought as he went to bed.

The young painter hung the painting on the wall of the single room in which he worked and in which also he and his wife slept, ate and lived. It gave him great pleasure and he came to think that the girl portrayed was a little like his wife. He always felt somewhat guilty about his wife. She was delicate in health and yet it was she who daily went to work in order to earn the money on which they both lived. Occasionally when she lost a job and they were desperate, he tried to get work himself – as he had done when he first went to see the executive – but somehow he always failed.

A few months later his wife told him that she was pregnant. Soon she would have to stop working. He decided to go and see his benefactor and try again for a job. The executive wouldn't hear of it. But, he said, I will lend you a hundred pounds. The young man hesitated. Finally, he agreed to accept the money but only on condition that he gave back the picture as security. I know, he added, that it is not worth that much, but at least it is a token. To spare the young man's feelings, the executive agreed. The painting went back into the cupboard.

It was a difficult birth and both mother and child were weak. The hundred pounds was spent. The young painter hadn't the face to go back to his previous benefactor. He went to another advertising firm and was given a job. In two years' time they were able to move to a larger flat. Then he went back to pay the £100.

The painter never gave up his job. But he came to an arrangement with the firm whereby he had Fridays off

in order to do his own work. The picture now hangs in their bedroom for, naturally, he is not often in his workroom.

The story, as you will agree, is not unusual. But since it is a story nothing need be hidden from the writer or the reader. I can tell you that the picture was painted by Carl Fabricius. Fabricius, a student of Rembrandt, was killed in an explosion when he was thirty-two years old. Consequently his works are very rare and very valuable. A newly discovered portrait would be worth about £20,000. But of course in life one can never know the whole story. In life it would be better if paintings were for looking at.

Index

Abstract art, 45–8, 76, 148

Action Painting, 66, 72, 114, 208

Affandi, 149

African art, 207

Amateurs, 53–7

Annigoni, Pietro, 43

Arcadia, 155, 198, 199

Armitage, Kenneth, 48

Art Autre, l', 33

Auerbach, Frank, 98–100

Austen, Jane, 177

Bacon, Francis, 56

Balzac, Honoré de, 191

Barker, George, 103

Baroque, 164

Beckett, Samuel, 31, 144

Bellini, 18

Berenson, Bernard, 154, 156, 157

Berkeley, Bishop, 94, 96

Blake, William, 141

Bohemia, 155

Bomberg, David, 94–6

Bond Street, 49–51

Bonnard, Pierre, 122, 134, 199

Botticelli, 133

Boucher, François, 174, 175, 189

Bourgeois culture, 71, 206, 211–13

Braque, Georges, 47, 101, 111, 113, 134, 150, 212

Bratby, John, 79–82

Brecht, Bertolt, 157, 191

Breuer, Marcel, 61–2

Buchenwald, 182

Buffet, Bernard, 31

Camus, Albert, 31

Capitalism, 34

Caravaggio, 164

Cézanne, Paul, 101, 102, 112, 127, 128, 145, 154, 158, 165, 168, 171, 172, 196, 199, 205, 212

Champaigne, Philippe de, 164

Chardin, 31, 44, 154, 174, 199

Chekov, 175

Child art, 65

Chopin, 17

Classicism in art, 17, 104, 174, 185

Claude, (Lorrain), 154, 168, 199

Colour, 133

Constable, John, 186, 197

Constructivism, 59–64

Content, 75, 76, 178, 209
Continuity of art, the, 105
Copernicus, 164
Corot, Jean Baptiste, 128, 154, 197
Courbet, Gustave, 196–8, 200
Criticism, 13–18, 66
Cubism, 94, 101, 111–16, 120, 137, 148, 172, 206, 212

Daumier, Honoré, 126, 187, 189
David, J.-L., 89, 171, 174, 185
Dean, James, 69
Degas, Edgar, 17, 128, 189
Delacroix, Eugène, 17, 101, 145, 184, 188, 197
De Quincey, Thomas, 92
Despair of the artist, the, 183
De Stael, Nicolas, 102
Dickens, Charles, 36
Dostoevsky, F. M., 191
Dubuffet, Jean, 70–72
Dufy, Raoul, 128, 134, 136–8

El Greco, 17
Eluard, Paul, 14, 125
Ernst, Max, 86
Existentialism, 98
Expressionism, 139, 149, 212
Extremism, 212

Fascism, 32
Fauvism, 134–5, 137

Flemish Renaissance painting, 153, 154
Form, 75, 178
Formalism, 45, 106, 152, 208–10
Fragonard, Jean Honoré, 174, 175, 176, 189
French Revolution, the, 174
Freud, Sigmund, 127
Fry, Roger, 143
Fullard, George, 96–98

Gabo, Naum, 58–64
Gainsborough, Thomas, 177, 185
Galileo, 164, 171
Galileo, 157
Gaugin, Paul, 35, 36, 37, 201–4, 212
Genius, 175, 201, 205
Géricault, Théodore, 126, 148, 186
German painters, 139, 186, 187
Germans, the, 117–21
Giacometti, 31, 73
Gillray, James, 178
Giorgione, 146, 198
Giotto, 205
'Glamour', 124
Gonzales, 167
Gorki, Maxim, 93, 211
Goya, 17, 126, 154, 155, 180–4, 187
Gramsci, Antonio, 209
Greuze, J. B., 174, 191

Index

Gris, Juan, 111–13, 128, 205, 212

Guernica, 129–30, 210

Guttuso, 103

Hepworth, Barbara, 75–9

Herman, Josef, 90–4

Hero in art, the, 211–12

Heroic art, 124

Hikmet, Nazim, 167

Hiroshima, 182

Hiroshima panels, the, 40, 73

Hogarth, William, 178, 191

Hokusai, 180

Horse's Mouth, The, 80

Idol, the, 211–12

Imperialism, 47

Impressionism, 33, 67, 199, 208

Industrial Revolution, the, 187

Ingres, Jean–Auguste–Dominique, 127, 185, 199

Ireland, 142–50

Italian Renaissance painting, 153, 154

Klee, Paul, 39, 64–5

Kokoschka, Oskar, 138–41

La Tour, Georges de, 166, 167

Le Brun, 165, 166, 174

Le Corbusier, 124

Le Nain, Louis, 165

Le Nain, Mathieu, 165

Léger, Fernand, 18, 88, 89, 113, 115, 121–5, 134, 142, 213

Leonardo da Vinci, 184

Lipchitz, Jacques, 101, 113–16

Louis XIII, 171

Louis XIV, 163, 165, 171, 174, 176

Louis XV, 176

Lust for Life, 34

Maillol, Aristide, 108

Malevich, Kasimir, 57

Malraux, André, 31, 182, 183

Manet, Edouard, 196

Mantegna, 17, 170

Marini, 31, 116

Marx, Karl, 166, 186

Marxism, 92, 199

Masaccio, 208

Materialism, 60, 197

Matisse, Henri, 16, 86, 106–9, 128, 132–6, 212

Michelangelo, 18, 122, 124, 155, 189, 190, 206

Millet, Jean François, 92, 189–91, 193

Minton, John, 66

Modigliani, Amedeo, 40

Mondrian, Piet, 101

Monet, Claude, 189

Moore, Henry, 83–5, 115

Morality and the artist, 189
Morland, George, 177–9, 185
Mystery in art, 167

Napoleon, 187
Naturalism, 44
Negro sculpture, 127
Newton, Sir Isaac, 187

Orozco, José Clemente, 205

Patronage, 50–1
Peninsular War, 182, 183
Perspective, 161
Philistinism, 41
Picasso, Pablo, 31, 69, 86, 101, 111, 113, 122, 125, 126–32, 154, 205, 207, 210, 212
Piero della Francesca, 157–62, 166, 170
Piero di Cosimo, 185
Pissarro, Camille, 36
Poincaré, Henri, 160
Pollaiuolo, 59
Pollock, Jackson, 66–70
Porter, Jimmy, 31, 32
Post-Impressionism, 212
Poussin, Nicolas, 17, 18, 88, 89, 164, 165, 168–73, 174, 189
Pre-Raphaelite movement, 154, 189
Pushkin, 185

Racine, Jean, 170, 174
Raphael, 170, 199

Read, Sir Herbert, 58, 62, 207
Realism, 208–9
Realistic Manifesto, 59–60
Rembrandt, 16, 17, 35, 92, 101, 154, 164, 171, 184, 196
Renaissance, the, 153–6, 165, 170, 171, 172
Renoir, Jean, 106, 199–200
Richards, Ceri, 85–87
Richier, Germaine, 72–75
Rimbaud, Arthur, 35, 195
Rivera, Diego, 205
Roberts, William, 88–90
Rococo art, 174
Rodin, Auguste, 116, 128
Romantic art, 17, 104, 143, 185–88
Rotterdam, 58–64, 116–20
Rousseau, J–J., 177, 186
Royal Academy, the, 41–5
Rubens, Peter Paul, 138, 154, 174
Ruskin, John, 193

Scientist, the, 157, 161
Sentimentality, 178
Seurat, Georges, 36
Shakespeare, 156
Shelley, 191
Sickert, Walter, 189
Signorelli, 59
Siqueiros, David Alfaro, 205
Smith, Matthew, 86
Socialism, 18, 191, 196, 198, 209

Index

Sophistication, 67, 73
Soutine, Chaim, 94
Soviet art, 42, 48
Sputnik, 63
Status of the artist in society, the, 210–11
Stendhal, 111, 185
Stubbs, George, 177, 186
Students, 51–3
Subject matter, 75, 209
Success, 80, 210–11
Surrealism, 14
Swinburne, A. C., 194

Tachism, 32, 66, 208
Ten Holt, Friso, 100–5
Tennyson, 192
Thomas, Dylan, 66, 85, 87
Thoreau, Henry David, 142
Titian, 44, 155
Toulouse-Lautrec, Henri de, 35, 127
Tura, 155
Turner, J. M. W., 185

Utopian art, 125, 141

Van Eyck, 166
Van Gogh, Theo, 36
Van Gogh, Vincent, 17, 34–8, 102, 133, 189, 201, 212
Velasquez, 166, 171
Venice Biennale, the, 45–9, 56, 57
Veronese, 89, 102, 135
Victorian art, 42, 192–5
Vorticism, 94
Vouet, Simon, 164, 165

Ward, James, 186
War monument, 117–21
Watteau, Jean Antoine, 17, 144, 154, 174–6
Watts, George Frederick, 189, 192–5
Wilkie, Sir David, 179

Yeats, Jack, 142–50
Yeats, W. B., 16, 146, 148, 150

Zadkine, 97, 114, 116–21
Zola, Emile, 36, 191

The Writers and Readers Publishing Cooperative

was formed in the autumn of 1974.

We are a cooperative collectively owned and operated by its worker-members, several of whom are writers.

We are members of the Industrial Common Ownership Movement.

Our policy is to encourage writers to assume greater control over the production of their own books; and teachers, booksellers and readers generally to engage in a more active relationship with publisher and writer.

We attempt to keep our overheads as low as possible so as to keep our book prices down, and thereby benefiting readers.

We welcome response which will tell us what readers wish to read.

If you would like to be put on our mailing list and receive regular information about our books, please write to:

Writers and Readers Publishing Cooperative
25 Nassington Road London NW3
175 Fifth Avenue New York. NY 10010